T0349059

THE GOLDEN AGE OF BEER

THE GOLDEN AGE OF BEER

A 52-WEEK GUIDE TO THE PERFECT BEER FOR EVERY WEEK OF THE YEAR

TOM ACITELLI

APOLLO
PUBLISHERS

The Golden Age of Beer: A 52-Week Guide to the Perfect Beer for
Every Week of the Year
Copyright © 2025 by Tom Acitelli

All rights reserved. No part of this book may be used or reproduced in any
manner whatsoever without the written permission of the publisher, except in
the case of brief excerpts in critical reviews or articles. All inquiries should be
sent by email to Apollo Publishers at info@apollopublishers.com. Apollo Publish-
ers books may be purchased for educational, business, or sales promotional use.
Special editions may be made available upon request. For details, contact Apollo
Publishers at info@apollopublishers.com.

Visit our website at www.apollopublishers.com.

Published in compliance with California's Proposition 65.

Library of Congress Control Number: 2022947419

Print ISBN: 978-1-954641-26-6
Ebook ISBN: 978-1-954641-27-3

Printed in the United States of America.

TO THE BEER HUNTER
MICHAEL JACKSON,
WITH THANKS.

CONTENTS

IN THE BEER WORLD, STYLE IS EVERYTHING 1

BEER IN WINTER 13

December
Tripel 15
Porter 19
Roggenbier 24
Christmas Ale 28

WHAT ARE WE TALKING ABOUT WHEN
WE TALK ABOUT "CRAFT BEER"? 34

January
Nonalcoholic 44
Barley Wine 51
Baltic Porter 55
Cream Ale 59

REMEMBER, IT'S SUBJECTIVE: THE BREWING
PROCESS AND HOW IDEAS BECOME
BEER STYLES 65

February
Gueuze 70
Berliner Weisse 74
Doppelbock 79
Imperial Stout 83

BEER IN SPRING 89

March
Brown Ale 90
Double India Pale Ale 94
Stout 98
Japanese Rice Lager 102

FAD CHANCE: WHY SOME TRENDS IN BEER
STICK AND OTHERS DON'T 106

April
Vienna Lager 112
Pale Ale 117
Helles 121
Kölsch 125

THE BREWPUB IS BORN: HOW TAPROOMS AND
RESTAURANTS WITH A BREWERY IN THE
BACK CAME TO BE 128

May
Kentucky Common 135
Maibock 140
Mild 143
Pilsner 147

BEER IN SUMMER 155

June
Mexican Lager 157
Gose 162
Golden Ale 165
Framboise 169

CAN DO: A HISTORY OF BEER PACKAGING 172

July
New England India Pale Ale 178
Bière de Garde 185
Saison 189
Kriek 194

BORN IN THE USA:
BEER STYLES NATIVE TO AMERICA 200

August
India Pale Ale 209
Light Beer 214
India Pale Lager 220
Weissbier 224

BEER IN FALL 229

September
Witbier 230
Steam 234
Braggot 240
Märzenbier 244

OUT OF THE BOX 249

October
Dunkel 250
Altbier 254
Bitter 258
Pumpkin Ale 263

WHEN MICHAEL MET BERT . . . 268

November
Rauchbier 270
Dubbel 274
Dortmunder 279
Scotch Ale 283

AUTHOR'S NOTE 287

PHOTO CREDITS 291

NOTES 295

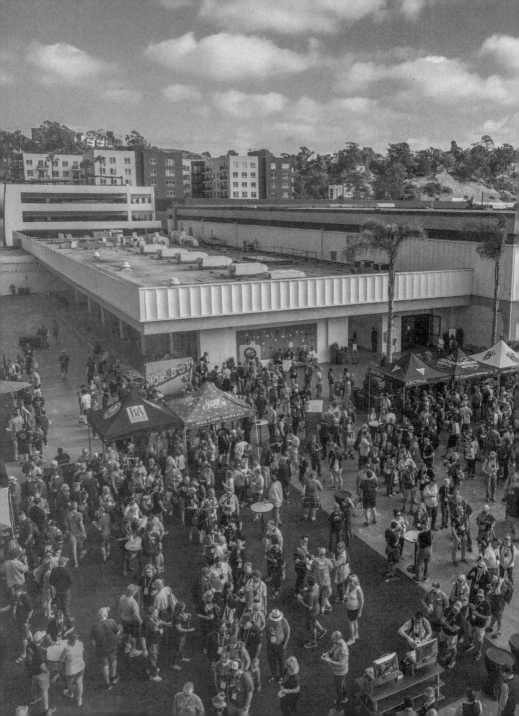

IN THE BEER WORLD, STYLE IS EVERYTHING

What is commonly believed to be the earliest version of beer was brewed at least four millennia before the common era in the mountains of what today is northwestern Iran—though there might be an even older candidate in what's now southeastern China, where the residue of what's believed to be a nine-thousand-year-old beer was recently uncovered.[1] Either way, beer is a very old beverage. And it's morphed over its long history. In its earliest forms, beer was simply fermented grain—and usually not the barley that undergirds it today, but rather grains such as wheat and rye. Hops, now a definitional part of the drink, were not regularly used, and the role of yeast in converting sugars wasn't understood until about a century and a half ago. Beer from antiquity would have been a brothy, sweet concoction that tasted like a granular breakfast cereal.

The version of beer that we recognize today—made from a malted grain, usually barley, that's been fermented with

Opposite: The American Homebrewers Association's Homebrew Con in San Diego in 2023 featured 4,335 entries from more than 1,700 homebrewers. Homebrewing was legalized at the federal level only in 1978.

yeast and flavored with hops and a handful of other, lesser ingredients—is much newer, but it's still about five hundred years on. That means that no one reading this was even close to being alive when modern beer was invented. A lot of us were, however, around for the invention of beer style.

That's something we can thank Michael Jackson for.

No, not that one. This Michael Jackson (1942–2007) was a plump, jolly English journalist who favored owlish glasses and loud ties, and whose curls framed a face that seemed always on the verge of laughter. He looked like some TV writer's quick sketch of a rumpled academic, bumbling yet loquacious, and he was fun to be around—traits that perhaps contributed to him becoming the world's greatest beer writer as he infused his writing with a perfect blend of concrete takeaways and sociable warmth. This combination helped popularize his work long before a mastery of social media was required to make a product go viral, and Jackson quickly became the quintessential guide to beer for consumers and industry folks alike. Garrett Oliver, renowned gourmand and longtime brewmaster of Brooklyn Brewery, has said that Jackson was "arguably the single most influential voice in food and drink of the twentieth century."[2]

The job of world's greatest beer writer was wide open when Jackson landed it in the mid-1970s. Beer at the time was defined in the public mind (and by quite a few food

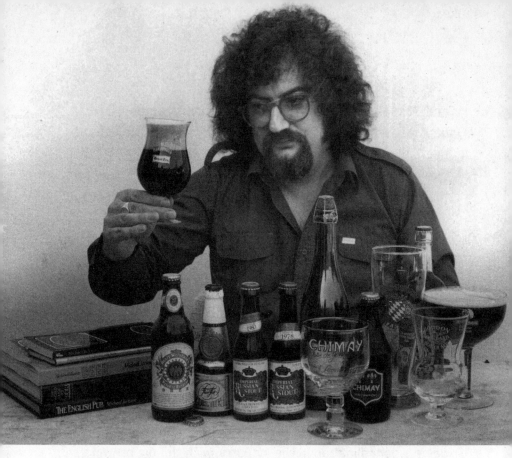

Beginning in the mid-1970s, the English beer critic Michael Jackson created the notion of "beer styles" and indeed invented much of the way that we talk about beer stylistically today.

writers and even the odd comedian)[3] by what it lacked: flavor, body, heft, distinction, and aftertaste (at least of the desirable sort). What was widely commercially available had evolved from a diverse range of styles and types into a monochromatic golden pale fizz. Jim Koch, the force behind Samuel Adams, once described beer from that time to me by calling it "alcoholic soda pop"—that is, a drink with little kick

and virtually no flair beyond its marketing. Indeed, what people back then likely remembered most about various beers were their taglines—"Great Taste, Less Filling" (Miller Lite); "the Champagne of Beers" (Miller High Life); "Head for the Mountains" (Busch); "This Bud's for You" (Budweiser)—and the commercials that featured these.

What had once been a diverse landscape of beer before Prohibition began in 1920 was a lot less diverse after its repeal in 1933. Pre-1920, the beer world had variety in styles and breweries. There were thousands of breweries across the country, with major urban hubs each boasting two or three of their own. These breweries produced a rainbow of styles and some of those styles were distinct to specific regions. A style of ale popular in the Northeast, for instance, might be impossible to locate in the Pacific Northwest. But Prohibition shut down all beer production, and after it came a consolidation in the industry, with the big breweries gobbling up the smaller ones, as well as a number of supply issues and engineering changes that further hastened a homogenization.

By the 1970s a handful of breweries made most of the world's beer, and they made it taste largely the same. What was on offer was designed to please German-American brewers and their customers and descendants, who, like their forebearers, typically preferred the lighter-tasting

lagers popular in Germany to the heavier ales of the British Isles. One beer that dominated the market as a result was Miller Lite. The first successful mass-market light beer, it was introduced by Miller Brewing in 1975. Beyond German-American consumers, it reached additional audiences by offering a reduced calorie count and a corresponding promotional plan that tapped into the would-be dieter and gym rat's insecurities, a marketing strategy so effective that it would pave the way for light beers to become the biggest beer sales category to date.

When everything available tasted largely the same, there wasn't much reason to care about the variation beer could offer, but Jackson changed that—despite his rise to prominence being as improbable as the rise in commercially available beer styles that he was responsible for. Born during the Second World War, he grew up in its austere aftermath, coming of age in a then-bleak Yorkshire in northern England with one sibling, a sister. Jackson's mother was from his hometown, and his father was a truck driver from Lithuania who had anglicized the family name, Jakowitz. Jackson had a warm relationship with his parents but didn't care much for formal schooling, which turned out to be fortuitous for beer and its fans as Jackson jumped into the writing trade—and its often bibulous culture—at the first opportunity in his late teens.

Around the same time he became a regular in his local pubs, a habit he would take south with him. By his thirties, Jackson was a reporter for Fleet Street newspapers in London and writing for television, and his connections led to an offer for him to pick up a dropped contract for a book on English pubs. He could now get paid for that taste for drink he'd first cultivated in Yorkshire.[4]

Jackson's first book, *The English Pub*, came out in 1976, and it was followed in 1977 by his book *The World Guide to Beer*, a richly researched yet easily readable guide in which he uncovered and toured a landscape of beer that scarcely seemed fathomable at the time. This included literal tours of major brewing nations such as the United States, West Germany, and Belgium, as well as up-and-comers such as Japan and France. Then there was the tour of styles that emerged from these travels and other research, introducing readers to lambic, kriek, porter, pilsner, rauchbier, altbier, roggenbier, barley wine, gose, gueuze, bock, eisbock, cream ale, rice beer, India pale ale, and a wealth of other styles. Jackson also covered notable beer regions and local traditions, festivals and folklore, fire-powered equipment, and specially shaped glassware. It was as if he unearthed a whole universe of beer hidden in plain sight, and on the verge of extinction in some cases. Most importantly, he revealed a wealth of options for what one could kick back

with, far more than the bland brew being showcased in the latest commercial for Miller Lite, which debuted in 1975 after careful test-marketing.

And shining a light on the wealth of beer varieties in existence at the time, despite a handful of brewers owning most of the market, was only half of what made Jackson's work so significant. He did something no one had done before by defining what we know today as *beer style* and then codifying various styles.[5] While other writers and industry pros had described types, varieties, and even "species" of beer, usually using broad descriptors such as "dark beer," "golden beer," and "sweet beer," Jackson mined the history and science of beer to define beer styles based on the unique techniques and ingredients used to make each of the categories he profiled. Each style considered how the brewer made the beer, how long the brewer typically took to make the beer, and what ingredients the brewer had used, particularly when it came to hops, beer's traditional bittering agent, and grain, beer's fermentation vehicle. (Grain is to beer what grapes are to wine.)

Maybe it was the old newspaperman in him, with that industry's myriad guides to how to write and its emphasis on developing a writing style, or maybe it was just luck, but Jackson's categorization of beers into styles—twenty-four in total in the first edition of *The World Guide to Beer*—

changed everything. And it couldn't have come at a better time. Organizations on both sides of the Atlantic—Campaign for Real Ale (CAMRA) in the United Kingdom and American Homebrewers Association (AHA) in the United States—had sprung up in the 1970s (the AHA in 1978, the same year *The World Guide to Beer* was published in the US), beginning as underground movements through which people fed up with the alcoholic soda pop that mass-market beer had largely become gathered and shared information. They reflected an audience thirsting for the wealth of styles that Jackson uncovered. When Congress legalized homebrewing at the federal level in 1978 (it had remained illegal even after the repeal of Prohibition in 1933, unlike home winemaking, which was legalized posthaste), the audience intrigued by the range of styles expanded even further. Homebrewers operating in the shadows could step into the light to share ingredients and information.

As the effects of this mass interest in diverse styles began to spill over into the commercial realm, small independent breweries started opening. In 1976, there was just one independently owned brewery in the United States making beer with traditional ingredients and methods. By the early 1980s, there were around twenty, some so small they were run by just one or two people with a license to brew and some secondhand equipment.

The rest of the few dozen breweries in the US in the 1980s were struggling regionals and mega-corporations such as Miller and Anheuser-Busch that all made the same yellowy, fizzy beer.

The rest is history. After Jackson's books were published, breweries multiplied and styles blossomed as brewers spun new interpretations of the styles that Jackson had written about. By the year of Jackson's death in 2007, there were more than 1,500 breweries in the United States, and that year's Great American Beer Festival included judging in seventy-five different style categories. In 2023 there were nearly 9,400 breweries and ninety-eight style categories, not including subcategories (for instance, Scotch ale was divided into peated and unpeated).[6]

With such a wealth of beer styles available, we are living in the golden age of beer. The fruits of Jackson's labor to define styles and the commercial efforts of those he inspired have led to a never-ending banquet of variety, rich in different tastes, smells, mouthfeels, and more. Where, then, to begin to make sense of it all and decipher how to best enjoy the beer on offer?

This book!

The Golden Age of Beer breaks down the style landscape of beer today, providing descriptions and background for fifty-two distinct and essential beer styles—

one for every week of the year—and tells the stories behind the styles, countering some long-held myths in the process (no, George Washington did not brew with pumpkins, and India pale ale was not invented for British soldiers in India). And perhaps more importantly, it explains what beer drinkers care most about: when and how to best enjoy and appreciate each style.

Beer has long been a seasonal beverage. Certain styles have always worked better at certain times because the underlying grains and other ingredients might be harvested at particular times in the year. And in the era before artificial refrigeration, some beers could only ferment in specific seasons due to the temperatures that the yeasts required, while other styles required cooler temperatures for aging. While beers are now available year-round, different brews maintain a seasonality to them, with warming notes, cooling notes, and tie-ins to annual calendar events.

This book takes the guesswork out of choosing the best beer style to unwind with in every season, and we'll review a few good examples of each style showcased. Incidentally, this is the first guide to vet new styles such as Mexican lager, India pale lager, and Kentucky common. Note that this isn't a history book, though there will be plenty of history—remember, beer is *old*—and while it's packed with info, it's not meant to be so dense that only the

initiated will enjoy it. Instead, it's a beer *journey*—one in which Michael Jackson and a panoply of brewers big and small will serve as our muses. Your palate is your vehicle, and the information to come is the fuel.

BEER IN WINTER

"Winter beers are as much a
state of mind as a style."[7]
—MICHAEL JACKSON

There is something about the lush heartiness of winter ales
and lagers that draws drinkers to them in the colder, darker
months. It's the warming quality of the generally higher
alcohol content, certainly, and the richness of the brews
that can complement winter's sweeter treats. As Jackson
observed, beer in winter also harkens to the preindustrial
age, when many brewers were farmers (or vice versa) and
beer was enwrapped in agriculture and its seasons. The
barley harvest in August meant beer aging by October and
ready for the solstice in late December. And because the
industrial age would perfect techniques that rendered beer
lighter and brighter than ever before, the darker beers of
winter recall the epochs when that was the only hue of all.

Opposite: A hops field lays fallow in the winter in rural Belgium.

It's something primal to hold a mug of thick, dark, warming grog today, the likes of which would've also been found on a cuttingly cold eve centuries earlier.

FIRST WEEK OF DECEMBER
THIS WEEK'S STYLE

$$\boxed{\text{TRIPEL}}$$

WHY NOW?

Because it's time to begin sampling beers for December holiday get-togethers, and the spicy, warming tripel is a strong, crowd-pleasing contender.

BACKSTORY

The dark, bracing, and slightly sweet tripel has been around since the Middle Ages, but the first commercial version of it wasn't released until 1932.[8] That was when the De Drie Linden brewery in Brasschaat, Belgium, just northeast of Antwerp, released its "Witkap Pater = Trappistenbier" (Witkap Pater = Trappist beer). The clunky name being in the guttural Flemish language belied its origins, since tripel did not originate in Belgium. Instead, it grew out of the monastic

brewing tradition, which developed over time in the monasteries and convents throughout Europe that had been brewing beer since at least the ninth century.

Tripel, like beer generally, was originally created partly for sanitary reasons. The mash for beer has to be boiled, which kills off most bacteria found in water supplies, and while it's unlikely early tripel brewers knew the science behind this, they likely did know that beer tended to be safer to drink than water. And brewing likely grew in popularity due to the hospitality edict for monks and nuns laid down by St. Benedict. Monasteries, especially, were to welcome the stranger and the traveler, and what better way than with a beer?

The first monastery to sell tripel in modern times was Westmalle, a brewery in the strict Cistercian, or Trappist, tradition of Benedictine monasticism. It's a charming place in a quaint exurban area of rural Flanders. The brewery is as modern as they come, and even though the monks are not directly involved in the brewing, the brewery can be called "Trappist" because it functions within a Trappist monastery and uses much of its proceeds for the order and its charitable works.

Westmalle's first commercial tripel came out in 1934 as, appropriately enough, "Superbier" (Super Beer).[9] The monastery renamed it Tripel in 1956, and today most tripel interpretations the world over are based on it.

ABOUT THE NAME

From the get-go, tripel was one of the strongest styles on offer. It was—and is—known for its high gravity (a brewing term roughly referring to the density of the beer before fermentation), high alcohol content, and unusual spiciness. Therefore, when it first emerged in the Middle Ages, brewers were said to have scratched three Xs onto its barrels. At a time when literacy was low, this XXX shorthand told potential consumers that what was inside was the strong stuff. *Tripel*—Dutch for "triple"—stuck as the name.[10]

TRIVIA

In 1986, on the 150th anniversary of the Westmalle brewery's founding, the monastery published a commemorative brochure with some advice about its beers, including the then-famous Trappist Tripel, for which the advice read: "Against loss of appetite, have one glass tripel an hour before mealtime; against sleeplessness, drink one Trappist."[11]

HOW TO SAMPLE

GOOD EXAMPLES Westmalle's Trappist Tripel is widely available in the United States and Western Europe for a monastic beer brewed in small batches. So is fellow Trappist monastery Chimay's tripel (the white label). The tripel from Allagash of Portland, Maine, is an excellent American example, as is Victory's Golden Monkey out of Pennsylvania.

TEMPERATURE Slightly cooler than room temperature.

LOOK FOR Like other beers perfect for wintertime, there's a lot of alcohol. But what really sets tripel apart is its spiciness: notes of coriander and even curry upfront with a lemony zest just underneath. Don't be fooled by tripel's typically pale color that may lead some to think it's a lighter brew. That color is from the pilsner malt grain used to make it; the drink is actually quite dense and full.

SECOND WEEK OF DECEMBER
THIS WEEK'S STYLE

WHY NOW?

Because this is prime holiday party season, and the roasted, often dark-chocolate taste of porter is a good counterbalance to sweet punches and desserts.

BACKSTORY

Porter developed in eighteenth-century England and was the first breakout beer style. It basically traveled wherever British imperialism did, which meant it was sold and consumed, if not made, on several continents at once.

The first written reference to porter may come from the English polemicist and poet Nicholas Amhurst. Amhurst was a Whig, or a supporter of the Hanoverian king George I. In a

pamphlet dated May 22, 1721, Amhurst warned that Whigs would rather be poor than submit to the previous Stuart dynasty again: "[T]hink even poverty much preferable to bondage; had rather dine at a cook's shop upon beef, cabbage, and porter, than tug at an oar, or rot in a dark stinking dungeon."[12] That Amhurst did not have to explain what porter was to his audience suggests it was a known style by 1721. That he placed it as a part of a poor man's meal suggests that it was widely consumed, as at the time most English were just scraping by.

What were Amhurst and others from the 1720s referring to exactly when they name-dropped porter? The likeliest theory is that the roasty, dark porter we know today evolved from what Londoners called "brown beer"— a general catchall for the drinkable fare in pubs (not to be confused with brown ale).[13] This brown beer was subject to increasing taxation on malts and the coal used to roast them to help pay for the United Kingdom's various wars, particularly its wars against France. In response, brewers saved money by cheapening the way they made brown beer. That included using wood-roasted malt, which left behind a smoky taste that brewers tried to compensate for by aging the beer more in the barrel. They also added hops to preserve the beer longer as it aged, and, more importantly, to compensate for the drop in alcohol that came with cheapening brown beer. What

emerged from these barrels was a wonderfully complex and well-rounded beer. The eighteenth-century brewers, just at the cusp of understanding the chemistry behind the processes, had had little idea that leaving a heavily hopped beer to slumber would add this complexity. But here it was: a deliciously toasty, slightly fruity beer that poured a darker brown than their prior brew and that, due to the extra aging, left behind a decent alcoholic kick.

The longer process for making this new style favored larger brewers. They could afford the longer aging and additional hops more than their smaller counterparts. These larger brewers also enjoyed relatively wide distribution channels, which guaranteed porter a wide audience (and provided that much more time for aging in transit). The larger players therefore made more of it and were able to ship it out of London and to the world.

Pale ale and especially pilsner would give porter a run for its money in the nineteenth century, and the style declined in popularity in the twentieth. Its embrace by American craft brewers—California's now-defunct Anchor Brewing released the first new post-Prohibition porter in 1975—reinvigorated its reach.

ABOUT THE NAME

The style's name comes from its popularity among the thousands of porters who plied their trades in eighteenth-century London. These included porters charged with unlocking ships at what was then the world's busiest port and those who delivered goods, including beer, throughout the capital. Myths—including the one that Ireland's famed Guinness Brewery came up with the name "porter" to distinguish one of its brands from its stout—have emerged in the past two centuries to explain the name, but these have no evidence behind them. Contemporary accounts from eighteenth-century London bolster the explanation that ties the style to the porters of that era.[14]

TRIVIA

You know who was a big fan of porter? George Washington. His pre–Revolutionary War correspondence with London merchants from his Virginia estate is peppered with requests for the style, including these from the late 1750s: "1 Hogshead best Porter" and "12 dozn. fine Porter Bottles."[15] Porter was probably the most popular beer style in the new United States.[16]

HOW TO SAMPLE

GOOD EXAMPLES Try feasting on Mayflower's Porter, Founders's Porter, Great Lakes's Edmund Fitzgerald Porter, Sierra Nevada's Porter, and Deschutes's Black Butte Porter.

TEMPERATURE Room to cool.

LOOK FOR A good porter should pour dark brown and thick, with a luscious head that doesn't fade until the last sips. There should be little noticeable carbonation. A velvety mouthfeel should reveal hints of black cherry and blackberry, as well as a pronounced smokiness all the way through. There are also imperial porters and those seasoned with spices, chocolate, and coffee. This isn't a high-alcohol style; the ABV ranges from 4 to 8 percent.

ROGGENBIER

WHY NOW?

Because the darkest days of the year are the ideal setting for contemplating this rare and rewarding style. An esoteric, hard-to-find brew, this is an impressive gift for the beer lovers in your life.

BACKSTORY

Roggenbier was born in the Middle Ages in what's now southern Germany. It was defined entirely by the unusually copious use of rye in brewing rather than barley or wheat. Interestingly, some German brewers took on rye as a quarter to half of the grain used in a brewing session even though rye was—and is—much more difficult to brew with. Rye is a huskless grain that absorbs a lot of wa-

ter in the mash, making for a particularly gummy churn during brewing. Still, there was something about the tangy spiciness of the rye that kept roggenbier alive as a regional style.

Then came the famed Reinheitsgebot in April 1516. The ruler of beer-mad Bavaria declared that henceforth in his realm brewers would only be allowed to use water, hops, and barley. Any other fermented grain beverage couldn't market itself as beer. Duke Wilhelm IV's purity law was devised to serve three purposes: to stabilize beer prices, to largely ban the use of wheat in brewing so it could be reserved for bread, and to rid the market of unscrupulous brewers who used a kaleidoscope of ingredients, including some, like soot, that were downright dangerous. The Reinheitsgebot and its lingering effectiveness, which far outlasted the Dukedom of Bavaria itself, ended widespread roggenbier production. There were probably no breweries making it by the twentieth century.

The change that allowed roggenbier a second life came in 1987 when the European Court, the top judicial arbiter of the emerging European Union, decided that the Reinheitsgebot and its legal precedent violated the EU's rules. This meant that German breweries using ingredients other than water, hops, and barley could thereafter market their finished fermented beverages as "beer," and soon

the first commercially available roggenbiers from German brewers in many, many decades began appearing. American craft brewers picked up the style in the 1990s and 2000s.

ABOUT THE NAME

Roggen means "rye" in German, and up to half the grain bill in a roggenbier might be rye.

TRIVIA

So lost to the mists of time was roggenbier that even Michael Jackson's revised *World Guide to Beer* in 1988 didn't mention the style. The Great American Beer Festival first introduced a "rye beer" judging category in 2001. It had thirteen entries then. Before that, any roggenbiers were generally entered in the "specialty" or "experimental" categories.

HOW TO SAMPLE

GOOD EXAMPLES Like other more esoteric styles, it's remarkable how many roggenbiers there are—beer drinkers nowadays are adventurous and the market has responded. Try Founders's Red's Rye IPA, Sierra Nevada's Ruthless Rye IPA, Bear Republic's Hop Rod Rye, and Jack's Abby's Sibling Rye-valry.

TEMPERATURE Cool to cold.

LOOK FOR Spiciness in the aroma, bready black pepper in the taste, and a light bitterness in the finish (unless it's a roggenbier paired with an IPA recipe, in which case it will be more bitter). The color should pour coppery orange to brownish red and there should be a thick, lasting head and a dense, sometimes cloudy body. Roggenbiers come in at around 6 percent ABV.

FOURTH WEEK OF DECEMBER
THIS WEEK'S STYLE

(CHRISTMAS ALE)

WHY NOW?

Because it's Christmastime and the winter solstice, and this is one of the more lusciously warming styles around. Reward yourself for curating a wonderful year of beer!

BACKSTORY

Humanity has been brewing dark, rich, thick beers for Christmastime for centuries, either to sell commercially or to enjoy personally, perhaps in front of a roaring hearth. Modern Christmas beer in the United States appears to have been born a little over a century ago. A Bavarian immigrant with the delightfully appropriate name of Peter Barmann started a brewery in Kingston, New York, about ninety miles north of New York City, and in 1915 released

what its packaging described as a "Special Christmas Beer." It was actually a doppelbock that, according to the packaging, had been "made months ago from rich malted barley, life-giving hops and grain, deep-rock spring water, filtered and boiled" [17] In other words, this was something to behold for the season. While it might not have been the very first Christmas beer, Barmann's Special Christmas Beer can certainly be held up as a rubric for the style as it evolved. Brewers would take existing darker, creamier, stronger styles, such as doppelbock, and lay on the spices—including nutmeg and allspice—and hops, making already complex beers that much more so.

The number of these seasonal offerings grew in a scattershot fashion post-Prohibition—Miller had a "Christmas Special Beer" beginning in the 1930s—but there was a twist. Most states after the repeal in 1933 banned references to "Christmas" or even "Santa Claus" in beer packaging, so "holiday" beers and similarly named ones proliferated instead.[18] There was, for example, Tannenbaum Beer from Wisconsin's Marathon City Brewing and Xmas Brew from Becker Brewing in Wyoming.[19] As rules eased, straight-up "Christmas" beers arrived, like Lithia Christmas Beer in the 1950s from West Bend Brewing, also in Wisconsin.

In November 1975, California's now-defunct Anchor Brewing released what it called "Our Special Ale." It had a Christmas tree on the label and the words "Merry Christmas

and Happy New Year." Anchor wielded important influence in the American beer market at the time. It was the last independently owned US brewery making beer from traditional methods and ingredients (what would come to be called "craft brewing"). It had released the first new porter in the United States since Prohibition, and its Liberty Ale, released earlier in 1975, would serve as a template for the rebirth of the India pale ale (and as the basis for Our Special Ale that November). Plus, Anchor made the prototypical steam beer, the trademark for which it would secure in 1978.

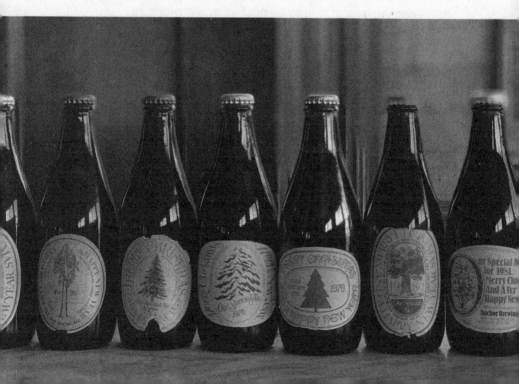

Anchor released "Our Special Ale" again in 1976, with the same "Merry Christmas and Happy New Year" plastered prominently around a viridescent conifer. The recipe wasn't the same, though. Anchor instead began a tradition of tweaking it annually, and Our Special Ale evolved into a warming, full beer with hints of spice and tastes of chocolate and caramel.

It was these early Anchor releases that established Christmas beer as a seasonal force in American brewing. Craft brewers, especially, poured into the space after the late 1970s, and any number of winter seasonal brews— linked by a similar opacity, strength, and complexity, and perhaps treacly cheerfulness on the label—appear like frost every November and December.

ABOUT THE NAME

Christmas ale is named after the major Christian holiday. Variations that don't specifically reference Christmas are "holiday ale" and "winter ale."

Opposite: Anchor Christmas Ale debuted in the late 1970s and set the tone for a rejuvenation of the style. A different tree species adorned the label of each year's release.

TRIVIA

The first beer to be marketed as "Hanukkah beer" came in December 2014 from the Shmaltz Brewing Company in New York state. The brainchild of Shmaltz founder Jeremy Cowan, the ale included eight different hops, eight different malted grains, and was 8 percent ABV—all none-too-subtle nods to the eight-day Jewish Festival of Light.

HOW TO SAMPLE

GOOD EXAMPLES Buckle up with these: Samuel Adams's Old Fezziwig, Tröegs's Mad Elf Ale, St. Bernardus's Christmas Ale, Great Lakes's Christmas Ale, Southern Tier's 2XMAS Ale, and Sierra Nevada's Celebration IPA (which will be hoppier than most, as it is famed for its infusion of fresh hops).

TEMPERATURE Room to cool.

LOOK FOR Christmas beers are busy beers. Look for a bubbly pour of deep ruby to black with a rocky, lasting head that leaves appetizing lace on the glass. There should be a sticky sweetness to the first taste and a chewiness on the finish with any number of spices wafting to the top, including cinnamon, cloves, allspice, and nutmeg. The bitterness will likely not shine or at least, depending on the brewery, not shine much. Instead, this style thrusts the malt into the

spotlight. Christmas beers tend to clock in on the north side of 7 percent ABV. This makes the style perfect for a post-prandial nightcap. Cheers.

WHAT ARE WE TALKING ABOUT WHEN WE TALK ABOUT "CRAFT BEER"?

Quick, define "craft beer."

Tough, right?

It's one of the great food and drink trends of the past half century, but "craft beer" and "craft brewery" remain hard to define. Why is that?

The terms first bubbled into wide use in the late 1980s, after a beer writer-turned-brewing consultant named Vince Cottone defined what he considered a "craft brewery" in his 1986 guide to the breweries and pubs of the Pacific Northwest.[20]

"I use the term craft brewery to describe a small brewery using traditional methods and ingredients to produce a handcrafted, uncompromised beer that is marketed locally," Cottone wrote, before taking things a step further: "I refer to this beer as 'true beer.'"

Cottone insisted that to be called "true beer," a beer had to be "hand-made locally in small batches using quality natural ingredients, served on draft fresh, and unpasteurized." He contrasted such beer with what he termed "industrial beers," or the beers of behemoth brands, such as Budweiser and Miller, that dominated the market. Cottone especially thundered against the industrial brewers' use of adjuncts like rice and corn, which he believed were "added to cheapen the beer."

In the end, it was Cottone's personal opinion that drew the line between true and industrial. Readers could take it or leave it. "I've chosen to call our ideal brew True Beer in order to distinguish it from brewers that I feel don't measure up to the standards set for the ideal, uncompromised beer," he wrote.

"True beer," as a term, did not have a long shelf life. "Craft beer"—an easy etymological spinoff from Cottone's "craft brewery"—did. By the twenty-first century, craft beer had become the thing people were talking about when they weren't talking about beer from Budweiser, Miller, et al. But that still leaves the little problem of what actually defines craft beer and craft breweries, and in the end, Cottone's initial approach turned out to be pretty prescient, though not necessarily in the way he had intended.

Before "craft beer" and "craft breweries," the most widely used terms to describe the non-Buds of the beer world were

"microbreweries" and "specialty beers" (and sometimes "micro-brews" and the like). The *New York Times* twice—in separate 1983 pieces on breweries in Silicon Valley and Manhattan—defined a "microbrewery" almost entirely in terms of its size.[21] These were breweries that "have sprung up over the past few years to produce a few thousand barrels of specialized beers each year for legal distribution."

What else defined craft beer? In one of those 1983 articles, the national newspaper of record described the beers of Manhattan's then-one-year-old Old New York Brewing Company as "made entirely from malt, which gives body to beer," and having a high hop content compared to "most major American beers [which] mix rice or corn with the malt to create a lighter, easy-quaffing beer," and therefore have a hop content that is "considerably lower."

The *Times* quoted Old New York's founder, advertising executive Matthew Reich, exhorting his fellow Gothamites to pivot from the industrial stuff: "People should drink locally brewed beer, it's as simple as that."

Ingredients mattered too, as did methods—a foreshadowing of Cottone's "natural ingredients" and "handmade locally in small batches." So the size of the brewery and its production, the ingredients it used, and how its brewers

Opposite: Craft brewhouses are pictures of modernity now after years of using second-hand equipment, often from other industries such as dairy. This is a temperature-controlled kettle at Rightside Brewing in Atlanta.

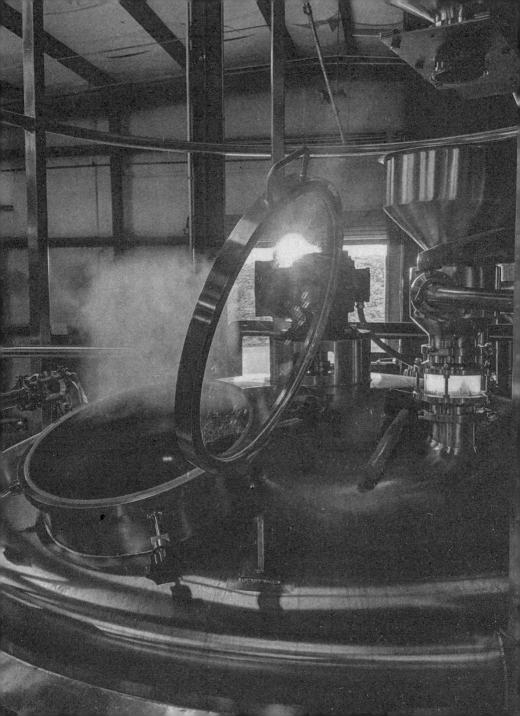

used them seemed to be the cornerstones of craft brewing as early as the 1980s. Why, then, did it take another twenty years for the term "craft" to reign supreme, and why are we still debating it all? For one, the Brewers Association did not codify a lot of this until the early 2000s. And in the intervening years, there was massive growth in the number of qualifying breweries. Cottone's 1986 guide to the breweries of the Pacific Northwest included all of nineteen entries (and that was only by including Canada's British Columbia). There were more than three hundred breweries in Oregon alone by 2022. This growth was largely fueled by mergers and acquisitions. Industrial-strength brewers had ignored their smaller brethren for years, but went on a shopping spree beginning in the 1990s. Some of the world's largest breweries now own small-batch brands. In 1995 Coors introduced Blue Moon, a wheat-based beer, or witbier, as a response to the rise of microbreweries. It looked like, and tasted like, beer from a microbrewery, but it was widely available. It was but one example of a macrobrewery making its own "small-batch" brand.

The demand for small-batch beers changed the way smaller brewers made, shipped, and marketed their products. Once-spurned adjuncts such as rice—a main ingredient in (gasp!) Budweiser—made it into craft beers. And some craft beers made it into gas stations, supermarkets, and other

retail outlets after having previously been the provenance of specialty food shops and gastropubs. It became much harder to say what was craft and what was not.

The Brewers Association, the main trade group for smaller American breweries, tried to clear the air in 2005. The group's parent companies had existed in one form or another since the late 1970s, but had never before attempted to define "craft beer" or a "craft brewer." In the fall of 2005, the Brewers Association board voted on a definition of "craft brewery" that hinged on three things: a brewery had to produce no more than two million barrels annually, it had to be mostly independently owned, and its flagship beer had to either be made from an all-malt recipe (no adjuncts!) *or* at least half of its beers had to be all-malt or use adjuncts only to enhance flavor, not to lighten it. This last part of the three-part definition, which the association titled "Traditional," was the longest.[22] Any beer, then, that was produced by a "craft brewery" as defined in 2005 was considered a "craft beer."

For a time, the Brewers Association's move seemed to settle things. Reporters, business analysts, restaurant professionals, distributors, suppliers, and the proverbial person on the street were all able to point to its definitions of craft beer and craft brewing. But the Brewers Association's definitions had a fatal flaw: they were based

A worker checks a fermentation kettle during brewing. Most breweries today use stainless steel vessels, though the odd brass, wood, or even brick kettle might still be found.

on the parameters of its dues-paying members. The largest member, the Boston Beer Company, brewed two million barrels annually, so that became the size cutoff. Almost all Brewers Association members were mostly independently owned.

"The reason for a definition was a pretty pragmatic one," Steve Hindy, cofounder of Brooklyn Brewery and a Brewers Association board member at the time, shared with me. "It was to define the population of brewers the Brewers Association was representing."

The definition, though, meant some craft breweries were no longer considered "craft" because they were not

independently owned. Things got even dicier when the Brewers Association adjusted its definition, first in 2007, then in 2010, then in 2014, and then again in 2018. In 2010 the trade group expanded the production cap for craft brewers from two million to six million barrels. Boston Beer Company and a couple other breweries were getting that big, though the vast majority of craft breweries measured their annual output in the thousands of barrels. (The big guys like Anheuser-Busch and Coors measured their production in the tens of millions.) In 2014 the Brewers Association okayed the inclusion of breweries that used adjuncts such as corn and rice unsparingly. Early craft brewery—and therefore craft beer—definitions had held all-malt recipes almost sacrosanct. Now adjuncts were in for the win, a move that was considered heresy to some and a case of "about time" for others. Many smaller, independently owned breweries were already experiment-ing with classic recipes that called for corn or rice—or aga-ve nectar, or unmalted oats, or syrupy Belgian candi sugar, or any number of other additions.

The 2014 move expanded the Brewers Association's umbrella, and with the change, D. G. Yuengling & Son, the oldest still-operating brewery in America and one that relied heavily on adjuncts, became the group's largest member overnight. Other larger regional breweries were able to join too.

Then in a 2018 definition change, the Brewers Association dropped any meaningful reference to traditional methods and ingredients. It kept the six million barrels cap and the mostly independent ownership requirement, but the third section of its definition, once the longest of the lot, defined a craft brewery simply as a brewery that "has a [federal Tax and Trade Bureau] brewer's notice and makes beer."[23]

Why the brevity? Some of the Brewers Association's larger members were making a lot of their money, if not most, from making beverages other than beer: hard cider, hard iced tea, hard seltzer. Removing the emphasis on traditional beer brewing freed them to do so and to remain a member in good standing. (The membership includes conferences, continuing education for employees, and, perhaps most significantly, the benefits of the BA's government lobbying.)

With the change, the 2005 definition—as good a one as had ever come along—was pretty much shredded. Critics and cynics took to print and the web to say the Brewers Association's definition had become pointless. That craft brewers themselves had backed the latest changes didn't seem to matter.

What did matter for most people by the start of the 2020s was the beer itself and not where it came from. The industrial brewers, as well as private equity firms and

even venture capitalists, were buying up beloved craft breweries such as Lagunitas, Stone, Goose Island, and Ballast Point—and the beers from these places tasted the same as before. Define it all you want on paper, in other words; the reality comes down to tang and aroma.

Today Vince Cottone's take from the mid-1980s, in the salad days of the craft beer movement, still holds: "craft beer" is up to the beholder, set your own definition. US Supreme Court Justice Potter Stewart famously wrote in a 1964 decision on obscenity, "I know it when I see it." Maybe it's the same with craft beer. You know it when you taste it.

FIRST WEEK OF JANUARY
THIS WEEK'S STYLE

(NONALCOHOLIC)

WHY NOW?

For many, it's the start of Dry January. The swearing-off of alcohol for the month has its modern origins in the early twenty-first century, though weeks-long alcohol fasts are nothing new. British royalty and nobility were said to swear off alcohol for the duration of World War I to save on grain and to show solidarity with the masses. The modern fast likely dates to 2013, when the charity Alcohol Change UK launched a Dry January campaign.[24]

BACKSTORY

There is a persistent myth that America's madcap experiment with Prohibition in the 1920s and early 1930s spawned non-alcoholic beer's general acceptance, if not popularity,

and that promoting it again decades later proved a piece of cake in the marketplace. The myth hinges on the supposed popularity of "near beer"—a beer-like beverage with the alcohol boiled off that had no more than the Prohibition-era legal ceiling of 0.5 percent alcohol by volume (ABV). Except it wasn't popular. Near beer never caught on, and most breweries still in operation dropped their offerings of it, in some cases well before the end of Prohibition. Instead they survived by selling other products such as cereals, pastas, and yeast—anything that turned raw grain into something salable—or even malt syrup, which could be used to make beer at home. Anheuser-Busch even turned over part of its massive St. Louis headquarters to the processing of slaughtered animals.[25]

The real precursor to nonalcoholic beer in the United States was the so-called "three-two beer" that arrived toward Prohibition's end in 1933. Legislation that President Franklin D. Roosevelt signed in March of that year sidestepped Prohibition's enforcing Volstead Act and put into effect the Cullen-Harrison Act, which allowed for a famously arbitrary 3.2 percent alcohol by weight or 4 percent by volume. In response, America's surviving breweries flooded the market with three-two beer virtually overnight. It became a sensation that carried the nation's beer drinkers through to December when the Twenty-First Amendment was ratified, ending Prohibition.

That end was the beginning of a literal and figurative land rush for larger breweries seeking factory space to meet the demands of the American beer market as it exploded in consumer growth. The new products were often stronger (sometimes significantly so) than 4 percent alcohol by volume, leading three-two beer to become the stuff of trivia and nonalcoholic beer to seem improbable. Why push other products when it was clear what the consumer wanted?

The first commercially available nonalcoholic beer in the United States—Clausthaler from Frankfurt, West Germany—arrived in 1979 and was followed by Kaliber, from Ireland's Guinness Brewery, in 1986. For a while it was these imports and perhaps one or two domestic stabs, including Anheuser-Busch's O'Doul's in 1990, that constituted the nonalcoholic beer market.

The twin big trends in American brewing through the 1980s and 1990s were an influx of lower-calorie light beers that packed a similar kick to higher-calorie ones, and the rise of craft beers, which tended to have as many as a few hundred calories per bottle or can and to tip 6 or 7 percent ABV. It was perhaps these trends, certainly the rise of craft beers, that set up nonalcoholic beer for its present-day renaissance. While versions of the most popular craft beer style, India pale ale, were

Opposite: A worker at Rightside Brewing in Atlanta clears spent grain from a kettle. Nonalcoholic beers, such as those of Rightside, undergo much the same processes as alcoholic ones.

clocking in at stunningly high alcohol levels—near 9 percent in some cases—beer drinking was declining overall. It dropped 0.2 percent in 2015 and then was down 3 percent on the year in 2022, according to the Brewers Association, with draft beer in particular in a yearslong decline by then. This was in part due to inroads that hard seltzer had made in the marketplace (the beverage would outsell vodka in the US in 2019), and in part because millennials coming into their buying power didn't

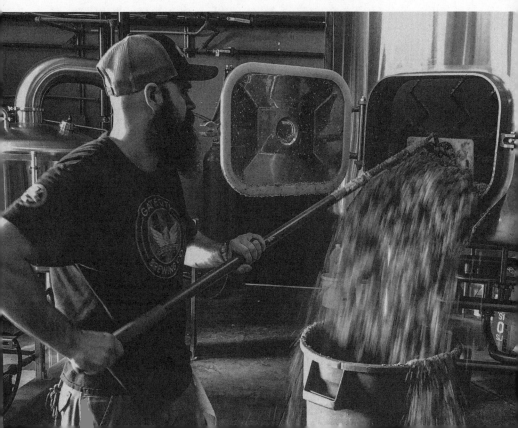

drink beer (or any other alcohol) as much as their pre-decessors. Craft breweries, it appeared, needed a boost.

California's Bravus Brewing Company was the first craft brewery in the United States dedicated solely to non-alcoholic beers. It opened in 2015, and others followed into the space. Soon, breweries big and small had nonalcoholic offerings. Some of these are quite tasty, just like the real thing in terms of ingredients and techniques, except with the alcohol almost entirely removed. And the fact that the non-alcoholic styles on offer were imitations of a variety of styles was a triumph in and of itself, as nonalcoholic beer up to this point had largely been an imitation of just one style, pilsner.

In 2019 the Great American Beer Festival, one of the largest beer festivals in the world, brought the nonalcoholic beer category back to its awards competition. It had dis-continued the category in 2004, when the space looked vanishingly small. In 2019, however, there were seventeen entrants, and by 2023 there were seventy.[26]

ABOUT THE NAME

Nonalcoholic beer is a beer-like beverage with very little alcohol—generally no more than the near beer of yes-teryear. Federal law requires any beer calling itself "non-alcoholic" to be less than 0.5 percent alcohol by volume.

TRIVIA

You see it on coasters, posters, and T-shirts: the line "I think this would be a good time for a beer," attributed to President Franklin D. Roosevelt. This quote is usually deemed to have been said by FDR the moment after he signed the Twenty-First Amendment, which ended Prohibition. But this is pure fiction.[27] Presidents don't sign constitutional amendments into law. He would sign the Cullen-Harrison Act, which legalized three-two beer, on March 22, 1933, but the quote in question was spoken to guests at a private dinner at the White House on March 12, 1933, according to a memoir by one person in attendance. The famously bibulous FDR was probably speaking very literally, saying that it was the time of evening when it'd be nice to have a beer.

Finally, FDR reportedly said, "I think this would be a good time for beer." No "a" before "beer." He was probably used to draft, not bottles or cans.

HOW TO SAMPLE

GOOD EXAMPLES Nonalcoholic beer is less a style than an approach to beer, so it is sensible to experiment by brewery and sample a range of breweries' nonalcoholic options. Bravus and Athletic make a variety of nonalcoholic styles that are worth trying, and other, larger craft breweries such as Sierra Nevada, Dogfish Head, and Boston Beer Company (the maker of Samuel Adams) also have nonalcoholic offerings, as do macro producers such as Anheuser-Busch and Heineken.

TEMPERATURE Cool to cold, depending on the style of the nonalcoholic beer.

LOOK FOR Some of the more widely available nonalcoholic beers have all the consistency and taste of the soggy, watery milk left over in your cereal bowl. But a number of smaller craft beer outfits have more nuanced offerings that can taste like the real deal. Read on for how different beer styles are supposed to taste.

SECOND WEEK OF JANUARY
THIS WEEK'S STYLE

(BARLEY WINE)

WHY NOW?

Because the days are short and the nights are long, and earthy, abundant barley wine is a particularly complex style fit for slow sipping paired with deep contemplation.

BACKSTORY

The author of a now-oft-cited 1736 book titled *The London and Country Brewer* wrote of different strengths of ale that could be found around England. These included a particularly strong one that "should not be tapped under nine months" and "is the most healthful." About it, the author wrote: "And this I have experienced by enjoying such an amber liquid that has been truly brewed from good malt, as to be of a vinous nature,

that would permit of a hearty dose overnight, and yet the next morning leave a person light, brisk and unconcerned."[28] In other words, this was one strong beer that could really knock you back. The bit about being "brisk" the next morning, we'll have to take the eighteenth-century author's word for—the important thing is that this description is perhaps the first reference we have to the only style of beer explicitly named after wine.

The description helps confirm that barley wine was around at least as early as the early eighteenth century. By the later part of that century, the in-house breweries of England's great estates were noted for their vinous brews. These estates were about the only places that could afford to make such a robust affair at the time. Within a century, though, English breweries such as Bass were brewing barley wines, and by the 1800s barley wine was a distinct and spreading style, though it took its time in spreading internationally. Barley wine was not popularized in the United States until 1975, when San Francisco's Anchor Brewing Company introduced its Old Foghorn, a barley wine–style ale. That was the first barley wine produced by an American brewery since Prohibition ended in 1933. Sierra Nevada would stomp into the space in 1983 with its Bigfoot barley wine, and craft brewers have been playing in the barley wine sandbox ever since.

ABOUT THE NAME

Most barley wines top 10 percent ABV, meaning they proffer nearly the same punch as wine, and many pour a dark ruby color reminiscent of red wine. They're also sweeter and less bitter than a lot of other beer styles, so naming the style using the word "wine" better reflected its taste. It's unclear, however, which brewery first used "barley wine" to describe it. Bass, for instance, released its barley wine in the 1850s as simply "Bass No. 1."[29] By the twentieth century, though, breweries including Bass were slapping "barley wine" on labels.

TRIVIA

According to Michael Jackson, the term "barley wine" spooked US regulators who thought consumers might be confused by it. Is it beer or wine? So they made early offerings such as Anchor's Old Foghorn describe themselves as "barleywine-style ale."

HOW TO SAMPLE

GOOD EXAMPLES Sierra Nevada's Bigfoot is the most widely available barley wine in the United States, and it exemplifies the style. It's only available from January to April, so take advantage of it now. Many smaller breweries also release seasonal barley wines in the winter.

TEMPERATURE Room to cool.

LOOK FOR A good barley wine should pour the color of dark licorice or cherry and produce a thick, lasting head that leaves plenty of lace behind. You should pick up hints of cherry, cinnamon, black pepper, fruit zests, caramel, chocolate, coffee, and toffee, and there should be some hoppy bitterness on the finish. Some experts will even taste leather. Barley wine is the sort of beer style that invites lingering, lengthy assessments because it really is that complex.

BALTIC PORTER

WHY NOW?

The third Saturday in January is Baltic Porter Day for brewers and beer fans in Poland, which claims this curious lager style as its own. Also, because it's the dead of winter—and Baltic porter is bracing and thick, with an alcoholic kick more akin to wine or even liqueur than beer.

BACKSTORY

By the late 1700s the world's most popular beer style was porter, if the success of English breweries' exports is any indication. The ale emerged from England and was best-known in the 1700s, as it is now, for being particularly dark and rich. It did well just about everywhere the English exported it. In the Baltics and Scandinavia, this success led

to local brewers making their own porter and its close cousin, the drier, slightly sweeter ale called stout. They were also copying the techniques of German and Czech brewers, whose lighter lagers, such as pilsner and the brownish dunkel, began edging out porter in popularity in the late nineteenth century.

In lager brewing the yeast that converts sugar to alcohol sinks to the bottom during fermentation amid much cooler temperatures than those used for top-fermenting ale brewing, resulting in a thinner, lighter-tasting beer. We get "lager" from the German word *lager,* meaning "to store," because brewers used to store their fermenting beers in cool caves or caverns before the age of artificial refrigeration. People in Scandinavia and the Baltics didn't need caves. They had cooler temps in spades. So when lager brewing reached their shores in the mid-1800s and many brewers embraced it even for porters, a dark, warming lager that mimicked porter and stout, the richest ales around, arrived on the scene.

ABOUT THE NAME

The classification "Baltic porter" comes from a series of articles that Michael Jackson wrote about the style in the 1990s. He added "Baltic" to his profile of certain porters to differentiate the style developed in the cool climates near the Baltic Sea from those that tasted very similar to the porters he had back home in England. Before

Jackson provided a name for what we today consider Baltic porters, porters were lumped together and the brewing process in places like Poland and Estonia was just thought of as those countries' way of making porter, without regard for the differences in the final porters created.

TRIVIA

Napoleon's blockade of Great Britain in the early 1800s helped Baltic porter's rise. Importers in areas along the Baltic Sea had trouble getting British beer because of the wine-loving French emperor's blockade, so they turned to brewers in their own backyard who saw demand for their brews boom.

HOW TO SAMPLE

GOOD EXAMPLES The Baltic porter from Polish brewery Zywiec, today a part of the Amsterdam-based Heineken juggernaut, is the world's best-selling version of the style. In the United States, Smuttynose in New Hampshire and Duck-Rabbit Brewery in North Carolina make excellent Baltic porters.

TEMPERATURE Room or slightly cooler.

LOOK FOR A strong alcoholic kick, up to 10 percent ABV in some cases; hints of toffee, chocolate, and caramel; a mouthfeel like a splash of whole milk; and a lot of leftover foam lacing—what remains from the foam beer head—on the glass afterward.

FOURTH WEEK OF JANUARY
THIS WEEK'S STYLE

WHY NOW?

Because January 24 is National Beer Can Appreciation Day. On that date in 1935, shops and grocers throughout Richmond, Virginia, put out green cans of cream ale from the Gottfried Krueger Brewing Company of Newark, New Jersey. It was the first time that canned beer had ever been sold commercially in the United States. The twelve-ounce American Can Company cylinders were made from heavy-gauge steel to tame the carbonation and were coated with tin on the interior and exterior. Drinkers had to puncture a triangular-shaped hole in the top.[30]

BACKSTORY

Cream ale is a lighter, sweeter break from the heavier, more bitter styles popular in winter. The style emerged from the American Northeast and the upper Midwest in the late nineteenth century, making cream ale one of the few beer styles born in the United States. At the time, golden-colored, crisp pilsner lager was sweeping the nation and much of the beer-drinking world. Then kölsch, an early German spin on the Czech-born pilsner, was introduced. It also tended toward golden in hue, but it could come across effervescently crisp, making it a marked departure from heavier, thicker ales.

More than one million Germans emigrated to the United States in the 1840s and 1850s, and with them came a taste for kölsch (and also an increased interest in beer that would turn cities such as Milwaukee and St. Louis into brewing hubs). There was a major challenge, though: the two-row barley, named for the number of kernels that developed in the stalk, that Germans were used to back home did not have much protein, which meant that the yeast could convert a lot more of the barley's sugar into alcohol during brewing, leaving behind a cleaner-looking beer; the most abundant barley in America, however, was the protein-rich six-row variety. The exhausted yeast, spurred by the excess protein, could only convert so

much of its sugar, leaving behind unappetizing detritus in lighter-colored beers. So to make their brews more closely resemble the kölsch back home, German-American brewers used rice and corn in the brewing process. These starchy adjuncts could convert to sugar for the yeast to feast on and did not have a lot of protein that might gum up the works. Their addition, while originally intended to make the brew mimic kölsch, ended up creating a whole new style: cream ale.

ABOUT THE NAME

It's got nothing to do with cream or anything dairy, for that matter. Instead, the name likely comes from the whiff of creamed corn that some early versions gave off through their dimethyl sulfide, a molecular byproduct that can emerge in brewing and that brewers can purposefully retain or weed out in fermentation and filtering.

TRIVIA

Genesee Cream Ale from the Genesee Brewing Company in Rochester, New York, was the best-selling ale in the United States during much of the late twentieth century. Lighter lagers were all the rage back then, but "Genny" carried the torch for ales. When Genesee introduced its cream ale in 1960, it debuted in unmistakable green cans and green-label bottles and was meant to be a middle ground between a heavier Genesee offering called 12 Horse Ale and a short-lived dry ale from the 1950s. (The name "dry ale" was more marketing than anything stylistic.)

HOW TO SAMPLE

GOOD EXAMPLES You can still get your hands on a Genny cream ale. Or enjoy the Brooklyn-based Sixpoint Brewery's exceptional cream ale, which it calls Sweet Action. There is also the seasonal Summer Solstice from Anderson Valley in Mendocino, California. The brewery doesn't call Summer Solstice a cream ale, but its style fits the bill.

TEMPERATURE Cold. Cream ale is what brewers sometimes call "lawn mower beer," a style meant to be thirst-quenching on a hot day of work.

LOOK FOR Sweet is the operative word. A good cream ale

is light on the tongue and in the finish, and not too bitter. And its flavor should reflect the grain used to make it, in the same way as some wines taste like grapes. Robust carbonation and a slight scent of creamed corn are also hallmarks.

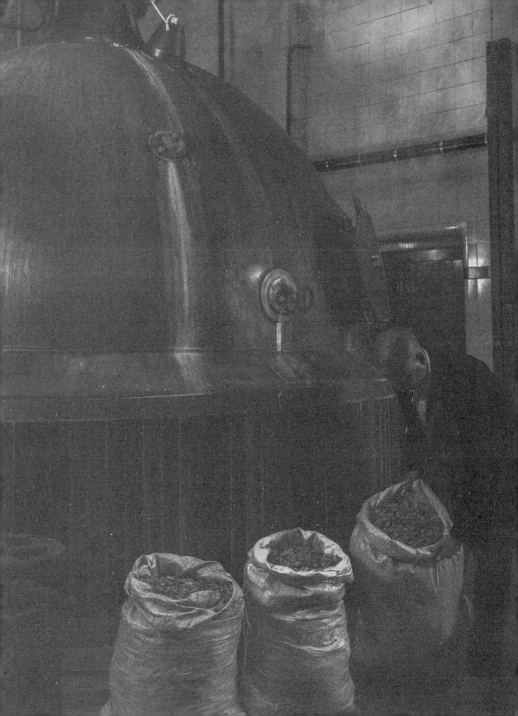

REMEMBER, IT'S SUBJECTIVE: THE BREWING PROCESS AND HOW IDEAS BECOME BEER STYLES

For a whiskey to be labeled a bourbon in the marketplace, at least 51 percent of its grain bill must come from corn; it must be distilled in the United States and aged in new, charred oak barrels; it must enter said barrels at no more than 125 proof; and it must be free of additives except water, which can only be used sparingly. To be called "straight bourbon whiskey," it must have aged at least two years in its barrels.

For wine to be labeled as a specific varietal, such as chardonnay, merlot, or cabernet sauvignon, US consumer guidelines require that at least 75 percent of the grapes used in making it come from that varietal. In the state of Oregon, this requirement increases to 90 percent for many varietals, including popular locally made wines like pinot noir, pinot gris, and pinot blanc. If a wine doesn't meet the

Opposite: Since the eighteenth century, hops have become the defining characteristic for many, if not most, beer styles. Here a worker adds hops at the Samuel Smith brewery in Yorkshire, England.

criteria, it has to be marketed as a blend or hybrid. In other words, the government has decided that in wine, what you're told you're getting should be what you actually get. Merlot wine means merlot grapes.

For beer, there aren't similar requirements. For a beer to be labeled an India pale ale or a pilsner or a porter or a rauchbier, it must have . . . well, nothing really, in terms of specific shares of ingredients or even particular characteristics. The government's not interested in

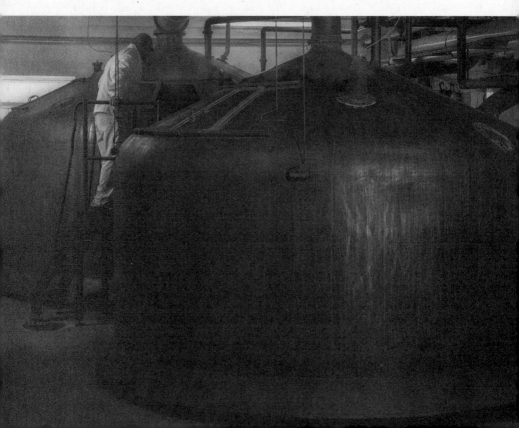

whether an IPA is hoppy or a barley wine is vinous or a milk stout's head lasts through the first several sips. The federal definition of "beer, ale, porter, stout, and other similar fermented beverages (including sake and similar products)" simply holds that a product can only be marketed as a "beer" if it contains at least "one-half of 1 percent or more of alcohol by volume" and is made from "malt, wholly or in part, or from any substitute," such as rice, bran, glucose, or sugar.[31] This requirement says nothing about hops or spices, where beer should be aged, or for how long. Instead its essence is: just make it from malted something or another, and then ferment it. Such a liberal federal latitude has allowed beer styles to flower in the United States, with brewers free to experiment and offer up new styles.

Beer is fermented grain typically spiced with hops. The grain is usually barley, but sometimes wheat or rye or a combination of these. The grains and hops undergo a robust boil along with any additives, such as rice or corn, and the resulting mixture is called the mash. Specific cultured yeast strains, some of them decades old, are added; at this stage, the mash is called the wort, which is essentially unfermented beer. Give that yeast time with the mash (a couple of days at most) and fermentation, or the

Opposite: Samuel Smith is one of the oldest breweries in England. It still uses brass, rather than stainless steel, mash tuns and other kettles. The mash tun mixes grains and other ingredients in the brewing process.

conversion of sugars to intoxicating ethanol, commences. The fermentation can last days or weeks, depending on what the brewer wants. Afterward, the beer is cooled and aged in stainless steel or wooden barrels. From there it can be kegged, canned, or bottled.

That's the brewing process in its basic form, and within it any number of iterations can pour forth under federal law. Hence the invention, almost as an afterthought, of enduring styles such as double India pale ale and India pale lager, or the birth from necessity of styles such as steam beer and Kentucky common, or the results of tinkering around the edges that produced cream ale and amber spins on altbier. This room to experiment has also led to often vast differences in body and taste of beers within the same style. The bitterness of an American pale ale from Northern California can burn the top of your mouth with its spiciness, while that of one from New England may feel as refreshing as a glass of ice water on a hot day. A mass-made pilsner from St. Louis may lack the heft of one crafted in small batches in Houston.

There are no hard and fast rules delineating what makes a beer style; history and tradition—as Michael Jackson showed—are our best guide. How and when did people make a certain beer, and what ingredients did they use? These are the foundations of a beer style, and styles are not defined by

percentages or proofs. This latitude is sometimes lost on even the most fervent beer geeks.

In the 1990s, a member of an Oregon homebrewing club emailed Tony Magee, a former paper salesman and home-brewer who founded the Lagunitas Brewing Company, to ask him to name the style of his latest seasonal beer. "I had never thought about that beer in terms of style," he would later share. "It just was as it was. So I planted my tongue firmly in my cheek and replied, 'It is a traditional Uzbeki Raga Ale.'" On seeing this, the homebrewing club's email listserv erupted with criticism and reproach, and the exchanges went on for a week. "Dogma and style and rigidly defined areas of doubt must form a backbone of security for many people," Magee wrote later as a reaction, "but they are chains to me."[32]

FIRST WEEK OF FEBRUARY
THIS WEEK'S STYLE

(GUEUZE)

WHY NOW?

Because gueuze is a particularly complex style perfect for contemplative long nights. Save one to drink by your favorite fireplace.

BACKSTORY

Gueuze was a well-established style by the end of the nineteenth century and dates back to at least the mid-1800s in Belgium's lambic-producing Pajottenland region, likely even to the seventeenth century, based on a reference to Pajottenland residents being able to carbonate their beers then.[33] What is known for sure is that at some point brewers began blending younger and older lambics—those drier wheat beers catalyzed by wild yeast—together to achieve

a secondary fermentation from the sugars in the younger lambic, thereby naturally producing carbonation. Initially, the blending and secondary fermentation was likely done entirely in casks, and the gueuze would be served directly from the cask. It became more common by the 1900s to do the secondary fermentation in tightly sealed bottles.

Until the advent of a more scientific approach to brewing, this blending of two or more batches remained in essence an art form. Sometimes the blends came out spectacularly; other times they fizzled out. By the end of the nineteenth century, brewers in Pajottenland had adopted a process not unlike the *méthode champenoise* used to make sparkling wine, and a consistency in the approach took hold. The secondary fermentations could still surprise in terms of carbonation levels—yeast *is* a living thing—and the taste complexities unleashed by such blending, but that's part of the fun of the style.

Gueuze from the late 1800s found a wider audience, at least in Belgium and other pockets of northern Europe, but it couldn't outrun the market realities hounding the lambic niche, including the commercial rise of lighter lagers like pilsner. Gueuze dwindled in popularity until Michael Jackson—who called it "that most sparkling of brews"— brought it to a modern audience in Western Europe and the United States in the late 1970s.[34] Notwithstanding this,

gueuze remains an esoteric style difficult to find outside of its homeland. But tracking one down—and letting it age for years or even decades (this author has one from 2008!) to perhaps add that much more complexity to the taste and to dry that taste out even more—is a good way to enjoy it.

ABOUT THE NAME

The most tantalizing theory behind the name holds that "gueuze" comes from the same Icelandic root as the word for "geyser"—*geysir*. That would be very apropos, as the bottles are often cage-capped like Champagne and open with the same sort of pressure-release pop. Incidentally, gueuze is pronounced with the same sound found in the word "cursor," as in that blinking marker on your computer—and it's French. The Dutch spelling *geuze* shows up sometimes too.

TRIVIA

Which is older: gueuze or the far more famous Champagne? Probably gueuze. (Sorry, wine snobs.) The beer almost certainly predates the wine, which was developed in the late seventeenth century. By that time, brewers were already blending lambics to get that certain fizz.

HOW TO SAMPLE

GOOD EXAMPLES Because gueuze can vary in taste, color, and carbonation from batch to batch, even bottle to bottle, it's probably better to seek out specific producers than brands. Boon, 3 Fonteinen, and Cantillon are noted Belgian producers that can be easy to find in Europe and some US specialty shops. The Lost Abbey Brewery north of San Diego produces an American homage called Duck Duck Gooze.

TEMPERATURE Room to cool.

LOOK FOR Enjoying a gueuze beer is like cracking a piñata, with a rush of multiple aromas and flavors. The pour should be especially bubbly with a sparkly, short-lasting head and a color that is straw to bronze or darker. For purists, the taste should be tart and sour. (Sweetened gueuze beers started hitting the market in the 1990s in an attempt to expand the style commercially.) This blended lambic style is made without fruit, yet hints of any number of fruits—pear, passion fruit, kiwi, banana—might pop up. The finish should be exceedingly dry, and gueuzes tend to get drier the longer they age. The alcohol content is generally 5 to 8 percent ABV.

BERLINER WEISSE

WHY NOW?

Because Valentine's Day is upon us, and the dry, bubbly, slightly fruity Berliner weisse is often compared to Champagne (sorry, Miller High Life). It may even be colored red.

BACKSTORY

By the early 1800s, Berliner weisse was a bubbly style popular in what later became northern Germany. Two ingredients defined it, and one of them is reflected in the name: "weisse" comes from the German word *weiße*, meaning "white." The word "white" in beer production always signifies a heavy use of wheat, as is the case with Berliner weisse. Early iterations included relatively few

hops and a grain bill that might have been half wheat and half barley. The wheat gave the style a refreshing lightness.

There were already plenty of wheat beers in northern Germany when Berliner weisse first gained traction. What made it a new style was the second defining ingredient: bacteria. Normally brewers would do everything possible to avoid infecting their beers, but somewhere along the line, either during brewing, fermenting, aging, or all three, *Lactobacillus*—a sugar-eating bacteria that spews lactic acid as a byproduct—made its way in, unbeknownst to brewers at the time. The result was a slightly acidic beer that tasted light and tart and came with a refreshingly clean and dry finish. Like Champagne, indeed.

It's unclear which brewery coined the name Berliner weisse, defining the wheat beer as a style made in and around Berlin. What is clear is that the style proved popular early on: nearly seven hundred breweries in the area produced a Berliner weisse at one point in the 1800s.[35] And along the way, both brewers and drinkers started adding syrups to Berliner weisse—green woodruff and red raspberry being the most popular.[36] While this added a dash of whimsy to the beer, there was also a practical reason: the syrups cut the acidity.

By the twentieth century, the number of German breweries making Berliner weisse had dwindled to the single digits. Pilsner lagers nearly swept the sour ale into the dustbin of

history, but that small handful of breweries kept it alive long enough for it be discovered by American craft brewers.

ABOUT THE NAME

Might Hamburger weisse be more accurate? The style that came to be closely associated with Berlin actually developed a couple of hundred miles to the northwest, in and around Hamburg.[37]

TRIVIA

The French emperor Napoleon Bonaparte pops up regularly in tales of beer history. This time it's with a look back to the first decade of the nineteenth century, when his troops invaded German lands and nicknamed Berliner weisse the "Champagne of the North," after their beloved French sparkling wine.[38] We can also find Berliner weisse in the history books in the seventeenth century, when French Protestants fled Catholic oppression during the intermittent religious wars that plagued Europe following the Protestant Reformation. One theory is that as they passed through beer-crazy Flanders in present-day Belgium, they picked up brewing techniques for what became wine-like beer.[39]

HOW TO SAMPLE

GOOD EXAMPLES Berlin's Berliner Kindl was one of the German breweries that held the torch for Berliner weisse through its decline beginning in the late nineteenth century and out the other side. It still produces one, though it's difficult to find stateside. Brooklyn-based Evil Twin makes a Berliner weisse called Nomader Weisse, and Schlafly Beer out of St. Louis has an apricot-infused iteration called The Eleventh Labor.

TEMPERATURE Cool to cold.

LOOK FOR That acidity should cut right through with a sour, fruity tartness. Berliner weisse often pours cloudy, as it's generally unfiltered (an ancestor of New England IPAs, perhaps?). Wait for an exceedingly dry finish, and don't worry if you're craving another: the alcohol content is usually below 5 percent ABV.

THIRD WEEK OF FEBRUARY
THIS WEEK'S STYLE

(DOPPELBOCK)

WHY NOW?

Because the traditional Christian season of Lent generally begins around this time, and the monks who invented doppelbock treated it as liquid bread to get through the season's fasting.[40]

BACKSTORY

Doppelbock is one of the few beer styles that can be traced to a single brewery and a single brewer. Monks who followed the rule of St. Francis of Paola, a fifteenth-century Italian hermit, began brewing beer near the Bavarian capital of Munich in 1634. For more than a

Opposite: A worker stirs in hops at the old Anchor Brewing Company in San Francisco. That brewery and several others made their names with thicker, richer ales during the colder months.

century the monks brewed beer for their own use, including a robust spin on the bock style, which came to be called doppelbock.

Doppelbock was first brewed for the April 2 feast day of St. Francis in 1774 by a monk named Valentin Stephan Still, who went by Brother Barnabas within the community. Brother Barnabas's brew was almost certainly in line with the stronger, denser beers that monks—and nuns—throughout Europe brewed to steel themselves against the long days of fasting during Lent, which typically begins in February and ends in April. Liquids were permitted, after all, even if solid foods were not.

When the monastery, located near the Isar River in the present-day Munich district of Au, began selling its beer commercially in 1780, its doppelbock was among its offerings. After Napoleon secularized the brewery, the brewery and monastery separated and the brewery took the name Paulaner, after the order's patron saint. The doppelbock lager became known by the Latin name Salvator, or Savior. Other German breweries would later make their own doppelbocks, and the interest in the style ultimately supported its survival through the pilsner wave of the late nineteenth century.

ABOUT THE NAME

Bock is the German word for "ram" or "billy goat," and *doppel* means "double," making the name "doppelbock" a misnomer. The name does not mean that a doppelbock is twice the alcoholic strength of a bock. It's more that it's a souped-up version: maltier, denser, heartier. "'Super Bock' might have been more accurate," Michael Jackson wrote.[41]

TRIVIA

How can you tell if a lager is a doppelbock without even tasting it? By the brand name. The original moniker "Salvator" proved so popular that hundreds of European imitators used the "-ator" suffix to pay homage to it without violating Paulaner's legal protection of its brand name. So, for instance, you get Spaten Optimator or Ayinger Celebrator. American brewers did not face the same legal strictures and have by and large abandoned this linguistic tradition.

HOW TO SAMPLE

GOOD EXAMPLES There are plenty of great domestic and foreign doppelbocks readily available, including the aforementioned Salvator, Optimator, and Celebrator from Germany. Domestically, try Samuel Adams's Double Bock and Tröegs's Troegenator.

TEMPERATURE Cool to cold.

LOOK FOR Doppelbock is supposed to be a bready, filling brew with a rousing alcoholic kick between 6 and 9 percent ABV. Hops do not play a big role, but malt does, so expect a sweet, rock-candy finish. The color is reddish to mahogany and the head is thick and lasting.

FOURTH WEEK OF FEBRUARY
THIS WEEK'S STYLE

IMPERIAL STOUT

WHY NOW?

Because imperial stout is the darkest, arguably warmest beer style, which makes it perfect for bitter cold February days. What's the point of a good beer if it can't do you some good?

BACKSTORY

If it hadn't been for Britain's bad roads in the eighteenth century, we might not have the exceedingly opaque, ultra-velvety style known as imperial stout. When the United Kingdom became the first nation to industrialize beginning in the 1760s, new power sources and manufacturing techniques led to scales of production the world had never seen before. That included new brewing technologies and

meant that breweries could produce more beer than ever before, including stout, one of the most popular styles of the time.

Problematically, however, beer was a perishable product and only so many barrels of it could be transported over the kingdom's poor roads to inns, taverns, and the like. So brewers hoping to move larger volumes of beer eschewed the roads and instead used the United Kingdom's canals, estuaries, rivers, and ports to transport their product. Once waterborne domestically, international shipping became a natural next step, and porter started to go global.

To help preserve them at sea, brewers made exported stouts denser than their domestic cousins by using more hops and, especially, more thorough malts. This thickness led to a second fermentation, during which more sugar converted to alcohol, and that meant stronger stout.

Sometime at sea in the late eighteenth century, imperial stout, a stronger version of its parent brew, was born. While we don't know when exactly, its birthday was definitely before the 1780s, when the Barclay, Perkins & Co. Brewery in London's Southwark, near the River Thames, started producing what it called "Russian imperial stout." Why call it that? Apparently, imperial stout had become particularly popular with Catherine the Great's royal court in St.

Petersburg, Russia. Even though it was a bit of a misnomer, the nickname stuck.

Barclay Perkins's imperial stout became the archetype for the style, enduring not only through Barclay Perkins itself, but also through a number of British and Baltic brewers into the late twentieth century. Its dark light did dim toward that century's close, but American craft brewers would resurrect it in earnest in the twenty-first century.

ABOUT THE NAME

"Imperial" slapped in front of any beer style has come to denote a stronger version of the original.

TRIVIA

In 1974 divers from Norway retrieved bottles of imperial stout from the 1869 wreck of an English ship named *Olivia* in the Baltic Sea. "A. Le Coq" was stamped on the bottles, as they had been the calling card of the pioneering wine and beer exporter Albert Le Coq, who was born in present-day Germany and worked out of England. Le Coq's firm would take over an Estonian brewery in 1910 to make imperial stout to slake demand and slice market share from Russian competitors.[42]

HOW TO SAMPLE

GOOD EXAMPLES Solid domestic examples of imperial stout abound: Sierra Nevada's Barrel-Aged Narwhal, Great Divide's Yeti, North Coast's Old Rasputin, Goose Island's Bourbon County Brand Stout, and Oskar Blues's Ten FIDY. Check for imperial stout at your local breweries too.

TEMPERATURE Room temperature.

LOOK FOR A toasty, roasty bouquet with a density and opacity that is rare in beer defines imperial stout, which should pour dark brown to black and sustain a buoyant, snowy head. There will be hints of bitterness, graham crackers, and toffee underneath an unmistakable maltiness. Imperial stouts of 6 to 10 percent ABV are the norm.

BEER IN SPRING

"Most beer lovers realize that brewing was once seasonal, but a March beer is a particularly poignant reminder of that."[43]
—MICHAEL JACKSON

That was Jackson in a March 1996 article for the monthly magazine *All About Beer*. He would elaborate by reflecting, "Throughout most of beer's history, March or April was the end of the brewing season."

Spring beers form a delectable bridge for the drinker between the heavier wares of winter and the lighter fare to come in summer. These are beers that, while sharp and distinct in taste and aroma, are also easy on the palate and belly. (One of the styles perfect for spring is literally called "mild.") Aside from a couple of selections, they are not particularly skull-cracking in alcohol content, as who wants a hangover when there's more daylight to enjoy?

Opposite: Barrel-aged beers, such as the ones from Samuel Adams maker Boston Beer, generally come out for sale in smaller batches. They are more expensive to make, partially due to the longer aging time.

(BROWN ALE)

WHY NOW?

Because the winter is starting to recede and things should be a wee bit brighter. Imperial stout from the previous week was dark, opaque even. Brown ale is, well, brown. However, like the first streaks of dawn through a dark sky, the promise of brilliance is there. Brown ale is a brilliant style in more ways than one.

BACKSTORY

Brown ale is named after its color, and that's got everything to do with the brewing techniques available around the time of its early eighteenth-century origin in England. Before the technological advances of that century and the early part of the next one, it was difficult for English brewers—or brewers

anywhere—to roast their malted grain to lighter colors. The process was cumbersome, exhausting, and prone to error. A longer roasting time usually produced darker roasts, especially when the roasting was at higher temperatures, and this meant that most commercially available beer ranged in color from brown to black and tasted more of malt than hops.

Mentions of brown ale in particular abounded in English books, newspapers, and travelogues by the mid-1700s. But did the color alone make a style? Yes, actually. Much of English beer, and beer elsewhere, grew paler in color after the technological changes. And paler malts with their higher yields of fermentable sugars gave pale ales a decidedly different taste and kick than brown ales, as did the more liberal use of hops. Brown ale then became a kind of evolutionary dead end. Most beers kept evolving, growing ever paler and hoppier, but brown ale stayed the same (though its brewers did change up the grain bill with dark malts other than the reliable brown, and caramel malt became a favorite).

The release of Newcastle Brown Ale in 1927 out of northern England's Newcastle Breweries cemented the style's survival. Brown ale's milder versions were staples of English pubs, and Newcastle would bring bottled and canned brown ale across England and overseas. American craft brewers picked up on the style beginning in the 1990s,

though true to form, they made brown ales that were hoppier than ever before.

ABOUT THE NAME

It is derived from the color of the beer, obviously. It also speaks to the simplicity of the style. What you see is what you get and it's been that way since the 1800s, when brewers got the technique and the science right with brown ale.

TRIVIA

A hoppy, sometimes hazy, always strong bitterness defines most American craft beers and increasingly much of the nation's beer in general. This was not inevitable. For a while, things were going in a maltier direction. Indeed, one of the best-selling craft beers to date is a malty brown ale, Pete's Wicked Ale, which Pete's Brewing Company debuted in 1986. The company's cofounder Pete Slosberg was a software engineer in the San Francisco Bay Area who homebrewed, and at one point he was trying to recreate the taste of Samuel Smith's Nut Brown Ale, a popular commercial take on the style from the United Kingdom. He nailed it on his fourth batch. His recipe became the basis for Pete's Wicked Ale, which, along with Samuel Adams's Boston Lager (a Vienna lager), basically drove US craft beer sales in the 1980s and 1990s.[44]

Slosberg and his partners sold Pete's to beverage giant Gambrinus in 1998, and Pete's Wicked Ale was discontinued in 2011.

HOW TO SAMPLE

GOOD EXAMPLES Why not start with Samuel Smith's Nut Brown Ale? Domestic greats include Smuttynose's Old Brown Dog, The Shed's Mountain Ale, and Brooklyn Brewery's Brown Ale.

TEMPERATURE Cool to cold.

LOOK FOR A good brown ale pours, well, brown, and has a thick, lasting head that leaves behind foamy lace on the glass. A nutty caramel aroma and taste starts things off, giving way to a mild bitterness on the finish with a lush toffee aftertaste. The alcoholic volume is usually no more than 6 percent ABV. It's a savory, inviting style that goes well with cozy surroundings and, if available, a roaring fire.

SECOND WEEK OF MARCH
THIS WEEK'S STYLE

DOUBLE INDIA PALE ALE

WHY NOW?

Because spring has started and it's time for crisper, lighter beers that aren't as heavy on the palate or the stomach. Spring beers should be refreshing.

BACKSTORY

While hard to believe now given its dominance of craft beer, India pale ale was once an obscure style from the history books that few brewers or even homebrewers made. By the early 1990s, though, breweries such as Lagunitas and Sierra Nevada had brought IPA back from the brink of culinary death. A crisp bitterness and distinctive alcoholic kick came to define the style. Then Vinnie Cilurzo, a young brewmaster at a small new brewpub called Blind

A worker at Southern California's Stone Brewing inspects the company's stainless steel fermentation kettles.

Pig Brewing Company, located sixty miles north of San Diego, took things a step further. In May 1994, Cilurzo began commercially brewing Blind Pig's first IPA, along with a pale ale and a golden ale, to launch the new brewpub. Worried that the IPA would have some off-flavors that might doom the whole batch—a turn the new brewpub couldn't afford—Cilurzo added more hops than was typical for an IPA at the time and some more malt to balance things a bit. What emerged was Blind Pig Inaugural Ale, a kind of souped-up IPA that Cilurzo astutely called a "double

India pale ale." It became one of the few beer styles born in the United States.

Cilurzo's California location undoubtedly helped the style spread. Both Sierra Nevada and Lagunitas were located in the Golden State, as were other breweries that had been crafting IPAs and especially hoppy pale ales. California drinkers were used to more bitter beers, so an even stronger IPA seemed a natural progression. By the end of the 2010s, the rest of the country had caught on and dozens of breweries were producing double IPAs.

ABOUT THE NAME

Vinnie Cilurzo, who today co-owns the famed Russian River Brewing Company in California, is credited with the name. "Imperial" also stands in for "double" with some of these stronger IPAs. And to add a pinch of confusion, some double IPAs are labeled "American pale ale."

TRIVIA

The equipment that Cilurzo used to brew that first double IPA came from "Electric" Dave Harvan, an eccentric ex-electrician who successfully lobbied Arizona lawmakers in 1987 to change the state's laws to legalize small breweries and brewpubs. Electric Brewing, out of Harvan's South Bisbee garage, was among the first small breweries in Arizona,

but a marijuana smuggling conviction put a stop to that operation and put his equipment on the market.[45]

HOW TO SAMPLE

GOOD EXAMPLES You should be able to find a good locally made double IPA at your closest brewpub or craft brewery. If not, the following solid examples are widely distributed: Russian River's Pliny the Elder, Dogfish Head's 90 Minute IPA, Bell's Hopslam Ale, Stone's Ruination IPA, 3 Floyds's Dreadnaught, and Night Shift's Santilli IPA.

TEMPERATURE Cool to cold.

LOOK FOR A double IPA should grab you by the lapels and slap you about with its bitterness. It's a cascading bitterness, one of crackling, carpet-unrolling intensity that slicks the tongue and just about overrides anything else save a tartness on the finish. There is one caveat, however: a more balanced double IPA should have something of a malt backbone supporting it, but it can take several sips to get to it once past the hops. The style's alcoholic strength usually lands between 8 and 10 percent ABV, or a little higher.

THIRD WEEK OF MARCH
THIS WEEK'S STYLE

STOUT

WHY NOW?

Because it's St. Patrick's Day this week and stout is the most popular beer style in Ireland, of which Patrick is the heavenly patron.

BACKSTORY

For a long time, "stout" simply meant a stronger version of the England-born dark beer porter, which was perhaps the world's most popular beer style in the eighteenth century. In other words, stout described a strong version of a style rather than being a style itself—as in stout porter, a strong porter. That changed in the eighteenth century as British brewing technology began to allow for new ways of roasting barley to create paler malts, a change that heralded the growth

of pale ales and similarly lighter-colored styles. The expense of such roasting, due in part to taxes on coal, left some brewers behind, including in an Ireland that the United Kingdom still controlled. They couldn't afford to make or to buy the paler malts and used darker malts instead.

A late eighteenth-century tax on malted barley instituted to help defray the cost of the UK's colonial wars, including against its thirteen colonies on North America's eastern seaboard, caused brewers to begin using less malt, and some began using additives to color their beers, including an additive to create the dark brown of porter. Some brewers cleverly used *un*malted barley, escaping the tax altogether. One of these brewers was Arthur Guinness II, whose family name graced a porter-producing operation out of Dublin that was already starting to take over the beer world. The use of unmalted barley gave Guinness's porter a distinctive bitterness that led Guinness to label it a stout (strong) porter. Soon after, Guinness dropped "porter" from the name and stout came into its own as a distinct style.[46]

In the years to come, there would be the drier Irish version (Guinness remains the standard) and the sweeter, often lactose-infused English version, which in the United States is often called milk stout. Some enterprising brewers even added oatmeal to their stout recipes, probably to

provide more body to the beer. While this "oatmeal stout" was out of fashion by the late twentieth century, Michael Jackson mentioned it in his 1977 *World Guide to Beer* and a beer importer in the US named Charles Finkel asked a client of his, the English brewery Samuel Smith (based in Jackson's native Yorkshire), to try its hand at one. The successful result led to oatmeal stout's resurgence in 1980.[47]

ABOUT THE NAME

The use of "stout" as an adjective to describe porter that was higher in alcohol begs the question of how "imperial" and "double" ever entered the beer lexicon later on. Why didn't brewers just use the adjectival "stout" for stronger versions of other beers? Stout IPA perhaps? Stout pilsner? There is no answer.

TRIVIA

Guinness trademarked its right-facing harp emblem in 1876, about a half century before Ireland gained home rule from the British. When the Irish Free State wanted to use the right-facing harp as the new nation's emblem, Guinness said no, so Ireland turned the harp around. The official symbol of what's now the Republic of Ireland faces left to this day.

HOW TO SAMPLE

GOOD EXAMPLES There are numerous domestic and international stouts, including the staples of Ireland: Guinness Extra Stout and Murphy's Irish Stout. Stateside try Deschutes Brewery's Obsidian Stout, Left Hand's Milk Stout, Duck-Rabbit Milk Stout, and Samuel Smith's Oatmeal Stout (made in Yorkshire, but widely available across the pond).

TEMPERATURE Room to cool.

LOOK FOR Roasted chocolate on the nose and to start, followed by a slightly bitter, dry finish. In between, there should be a velvety creaminess, especially with the sweeter milk stouts. This will clock in around 4 or 5 percent ABV—don't be fooled by the brown to black color and density, this style does not have a strong alcohol content.

FOURTH WEEK OF MARCH
THIS WEEK'S STYLE

JAPANESE RICE LAGER

WHY NOW?

Because the treaty that opened Japan to trade with the United States was signed March 31, 1854, and this light palate cleanser of a beer is a perfect celebration of East meets West.

BACKSTORY

The exact origins of commercial brewing in Japan remain contested: some accounts say the Dutch connected the Japanese with beer and brewing well before the nineteenth century, others cite a British influence, and still others say that it was the Americans in the latter decades of the 1800s who were the instigators. What is known is that Japan had become a brewing nation by the close of the

nineteenth century, and the style of beer that emerged as a result was an exceptionally clean, light-bodied, bone-dry lager with a little more heft to its body than similarly golden lagers elsewhere. What helped it attain that light body and color was rice.[48]

Just as nineteenth-century American brewers had used rice to essentially clean up spent barley and yeast, thereby producing lagers that were lighter colored and lighter tasting than those from Europe, Japanese brewers and their foreign influencers did the same in Japan. The popularity of rice-based sake—an iconic Japanese alcohol often described as a wine but made in a process more akin to brewing—surely furthered rice's acceptance in Japanese brewing.

Japan's biggest breweries—Asahi, Kirin Ichiban, Sapporo, and Suntory, which all have roots in the late nineteenth century—made Japanese rice lager through the twentieth century and into the twenty-first century.[49] In fact, their offerings in the style are pretty much synonymous with Japanese beer outside of Japan. It's hard to find a Japanese-made brand outside the country that isn't a rice lager or based on one.

Since about 2010, American craft brewers have embraced producing rice lagers as they have embraced the once-taboo use of rice in brewing. The adjunct had been dismissed as a shortcut for macrobrewers such as Anheuser-Busch, Pabst, and Miller, but rice has come to

be seen as a legacy of inventive brewers of yore. (Weren't the macro producers of today once the craft pioneers of yesteryear?) In 2014 the Brewers Association adjusted its definition of a craft brewer to include those whouse rice. Japanese rice lagers have gained popularity in craft circles ever since.

ABOUT THE NAME

The name is very literal in terms of its origin and its main ingredient. Much more spot-on than, say, the very popular India pale ale, which didn't originate in India and is sometimes far from pale.

TRIVIA

Japan's first modern brewmaster was Seibei Nakagawa. Nakagawa studied brewing abroad beginning in his late teens in the 1860s, including in Germany. He applied what he had learned abroad in his roles at breweries in Japan, eventually managing the brewing operations at the factory that became Sapporo.

HOW TO SAMPLE

GOOD EXAMPLES Asahi Super Dry, Sapporo Premium Beer, Upslope's Japanese Style Rice Lager (which comes from Colorado), and Harland's Japanese Lager (which comes from Southern California).

TEMPERATURE Cool to cold.

LOOK FOR A volcanically bubbly pour with a soft yet spiky, meringue-like head that lasts, and a clean, clear gold or straw color with enduring carbonation. This is a dry style balanced between bitterness and sweetness, and is exceedingly easy to drink. Any herbal hints of hoppiness are a byproduct of that balance, as hops are not necessarily used for bittering here. The alcohol content should not exceed 6 percent ABV.

FAD CHANCE
WHY SOME TRENDS IN BEER STICK AND OTHERS DON'T

In 1993 Miller Brewing Company introduced two new beers: Icehouse and Miller Clear. Each was supposed to pioneer a new style.

Icehouse was meant to embody what Miller referred to as "ice beer," a lager that was chilled during brewing to form ice crystals, which were then removed before the beer was aged. This was said to impart a higher alcohol content. Ethanol freezes at a much lower temperature than water, so removing those ice crystals supposedly prevented the beer from being watered down.

"Clear beer" was seemingly hatched whole cloth from the marketing whizzes at Miller. Since 1971 the brewery has had a trademark on the phrase "Miller stands clear," so perhaps Miller Clear was an example of an advertisement in need of a product. The beer was a nearly translucent lager, the result of repeated filtration, and rode the 1990s craze

of clear products that included clear mouthwashes and clear sodas. It had nearly as few calories as Miller's smash hit, Miller Lite, and was also low in carbohydrates, which led to a marketing strategy targeting health-conscious consumers. Miller looked, for a time, poised to spark a "clear beer" category, much as it had ignited the light beer wars of the 1970s and 1980s. Coors was said to be queuing up a clear competitor.

Alas, Miller Clear held on for less than a year. It was gone by early 1994, and the clear beer style was gone with it. Miller's Icehouse, however, held on, and with it was born the ice beer style—pale lagers with little bitterness, lots of wateriness, and a high alcohol content. Why one jumped from fad to trend to style while the other lost its fizz has to do with timing, media hype, marketing, accidents of brewing, the market, and competition.

Accidents of brewing and whether a new style fills a hole in the market are usually the best explanations for why a beer fad thrives rather than dies. The India pale ale craze is a good example. It was a style that dated back to the late 1800s but had fallen to such commercial lows by the end of the 1900s that it was in danger of extinction. Only a few breweries worldwide made IPAs, and only for limited markets. Then a handful of brewers and home-brewers began experimenting with adding more hops, or certain hops, to their ales and in a few short years in the

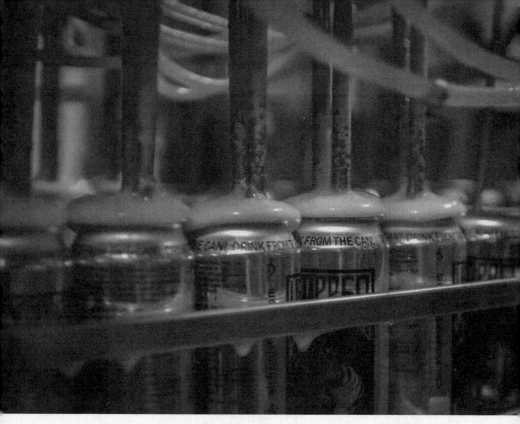

The Alchemist Brewery's canning line prepares a batch of the company's influential Heady Topper double IPA.

1990s, just as craft beer was taking off, the style morphed. Double IPA was invented by Vinnie Cilurzo in Northern California when he added hops in unscientifically copious amounts to simply cover any off-tastes in his debut beer. His accidental invention was a perfect match for consumers' growing desire for ever-hoppier beers, and IPA in all its glory toddled forth from there to become the fastest-growing beer style in the world.

Since the turn of the century there have been several beer fads that have not done as well. Nitro beers, for example, are nitrogenated (infused with nitrogen gas) instead of carbonated (infused with carbon dioxide) like most beers, leaving a creamier head and body. While Guinness had already been offering a nitrogenated beer for decades with its stout, craft brewers began offering them around 2010. But these craft creations would never fully take off. Though some breweries do them quite well and craft varieties can still be found, their sales never matched the hype behind them. Similarly, around the time that craft nitros started to show up in bars and on shelves, the session beer craze swept the United States. Lower-alcohol session beers were so named because you could drink more—often many more—than one in a session and not be too much worse for the wear the next day. Session beers' history stretches back to the nineteenth-century United Kingdom, and they gained favor in the United States as a reaction to the pinching hoppiness and alcoholic kick of IPAs. They also allowed brewers to cut costs by using fewer hops. Session beers, too, are still with us and now constitute a distinct style, but they're not market leaders.

Just before the arrival of nitros and sessions, a hazier, juicier take on IPA poured forth from northern New England: the New England India pale ale. It ticked just about every

box when it comes to why some fads stick. It was invented largely by accident, beer writers covered it widely (whether with glowing reviews or scathing ones), and it filled an apparent hole in the market left by the surplus of busier IPAs. The only thing it didn't need, really, was marketing; the hype did the hard work. For many years, a handful of smaller breweries continued to make most New England IPAs while the bigger players stayed away. Then, in 2018, the Brewers Association anointed the approach with an entry in its style guide, and that same year Samuel Adams debuted a New England IPA. It was a fad no longer—instead, long live the style.

A similar history could be given for nonalcoholic beer. Like IPAs, nitros, and sessions, nonalcoholic beers had been around for decades by the time they enjoyed a renaissance in the late 2010s. Here was an excellent example of great timing coming into play. IPAs were getting ever stronger in alcohol content, and new generations of consumers that didn't drink all that much—millennials and Generation Z—were coming into their spending power just as many older Generation X members were done with hangovers. To appeal to them, some of the fullest, tastiest nonalcoholic beers ever made were produced.

There are also beers that seem meant to stay fads. In 2015, Alexandra Nowell, a brewer at the Three Weavers Brewing Company in Inglewood, California, injected edible

glitter into an IPA when she kegged it. The glitter, made from complex sugars and pearlescent pigments derived from mica, caused the beer to sparkle after it was poured. Eventually, the glitter would settle at the bottom of the glass, but there you had it: glitter beer. The hype and media coverage soon followed, and the marketing was effortless: who doesn't like a little sparkle? Apparently, a lot of people. Glitter beer never made it beyond the fad stage and died in the new decade. You may find a few here and there, but glitter beer is far from becoming a lasting style.

Or is it?

Writing in 1994 about the end of Miller Clear for the UK newspaper *The Independent*, Michael Jackson described it as "a lager the color of 7-Up, which formed little head and tasted like a sweetened seltzer." Less than twenty years later, hard seltzer would become the fastest-growing alcoholic beverage in the United States. Maybe Miller was actually on to something. If so, maybe history will look back more kindly on glitter beer too. Then again, maybe not.

FIRST WEEK OF APRIL
THIS WEEK'S STYLE

(VIENNA LAGER)

WHY NOW?

Because Vienna lager is a great ballpark beer—its most famous version, Samuel Adams, is the official beer of America's oldest professional ballpark, Fenway, in Boston— and Major League Baseball's Opening Day typically falls this week.

BACKSTORY

Vienna lager was first made near Vienna, the capital of what was then the Austrian Empire. It was the product of the research of Anton Dreher, who had inherited his father's brewery, Klein-Schwechat, near the city, as a child in 1820, and who later studied the paler ales coming out of the United Kingdom. In particular, Dreher studied the kilning

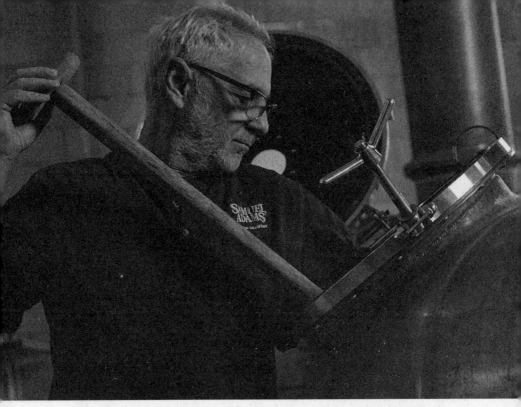

A brewer checks the mash at the Boston brewhouse of Samuel Adams's maker, Boston Beer. This brewhouse is used primarily to develop new beers.

techniques that the English used to produce paler malts. His brewery would produce a paler malt of its own that he called Vienna malt, which would undergird the lager of a similar name. The first barrels of Vienna lager rolled out in 1841 and helped make Klein-Schwechat the largest brewery in the Austrian imperial realm.

What made the beer so popular? Its color, for one. It was a shade of reddish amber—Michael Jackson's research likened it to "a very full old gold"—and this appealed both

in Germany, where consumers were used to dark brown and black beers, and outside Germany, where paler beers were in demand.[50] These included Märzenbier, which was developed by the elder Gabriel Sedlmayr, Dreher's traveling companion in the United Kingdom, and debuted in Bavaria in 1841, and pilsner, which was developed by a Bavarian brewmaster familiar with Vienna lager. To many drinkers, these paler beers were chic symbols of modernity. Vienna lager's malty, sweet taste and chewy finish probably helped its popularity as well.

Still, competition was tough and pilsner swamped much of the Austrian market, as it would most markets, leaving Dreher's Vienna lager to remain a Central European menu item well into the twentieth century. Then it became the basis for the best-selling American craft beer Samuel Adams's Boston Lager, which debuted in around thirty bars and restaurants in Boston in April 1985 and would skyrocket in popularity in the years to follow.

Jim Koch, a management consultant who became the principal founder of the Boston Beer Company, the developer of Samuel Adams, said their Boston lager came from an old family recipe from his forebears, who had been brewers in Germany and the United States.[51] Koch hired Joseph Owades, the biochemist behind the formula for light beer, to turn the family recipe into the Vienna lager that would become omnipresent. Owades—who also

consulted on recipes for Pete's Brewing Company and the Anchor Brewing Company, making him a largely unsung hero of the craft beer movement—was the son of immigrants from a region of the Austrian Empire now in present-day Ukraine.

ABOUT THE NAME

Dreher's Klein-Schwechat brewery is on the outskirts of Vienna, and it seems fitting that the Austrian response to the rise of pale ale in England and golden lager (a.k.a. pilsner) from present-day Czechia should be named for the Austrian capital.

TRIVIA

During Dreher and Sedlmayr's 1830s tour of breweries in the United Kingdom, Dreher would capture and smuggle out samples of pale ales using a hollowed-out walking stick with a valve at one end that he would surreptitiously dip into vats. The pair were then able to study the beers to brew their own paler creations.[52]

HOW TO SAMPLE

GOOD EXAMPLES You can't go wrong with Samuel Adams's Boston Lager. Also seek out von Trapp's Vienna Style Lager, Devils Backbone's Vienna Lager, Schell's Firebrick, and pFriem's Vienna Lager.

TEMPERATURE Cool to cold.

LOOK FOR A deep copper to reddish amber color with a fluffy, lasting head; malty, chewy sweetness at the start and the finish, with a little bitterness; not too heavy and not too strong—no more than 6 percent ABV.

SECOND WEEK OF APRIL
THIS WEEK'S STYLE

WHY NOW?

Because this style is remarkably diverse and beginning to sample options now will help you decide which ones to drink throughout the summer.

BACKSTORY

Pale ale emerged in England in the 1700s, and later that century left home for northern Europe. Its appearance defined it as a style early on: pale ale was lighter colored than other ales on the market, particularly inky black porter, which also enjoyed its first heyday in the eighteenth century. Maybe the lighter color was a reaction to porter's rise, as other brewers sought a way into the

market, or maybe it was just a natural engineering by-product of the style's development in the first nation to undergo industrialization. Whatever the reason, paler ales caught on commercially and kept selling.

English brewers achieved the lighter color—amber, straw, or shades of brown or red—through sometimes clumsy, usually painstaking roasting methods that often produced uneven results. They used rudimentary filtration techniques, often gravity-powered, to try and separate out spent yeast to achieve clarity. What they ended up with were paler ales—just not evenly colored ones. More evenness came to the color of the ales after the English engineer Daniel Wheeler patented a device in 1818 for roasting malts more uniformly. From then on, breweries, particularly northern English ones such as Bass and Samuel Allsopp & Sons, could produce reliably pale-hued ales that became more uniform in other ways too. These ales were malty, but not overly so, nor were they especially bitter, though a hoppier offshoot of the style began to gestate in the nineteenth century and later emerged as India pale ale.

Pale ales were relatively average in alcoholic kick and fast became a reliable seller for pubs and restaurants on both sides of the Channel. This fast growth led to the ubiquity of pale ale and almost guaranteed that it would

morph into myriad iterations only tenuously connected to the eighteenth- and nineteenth-century originals. By the end of the twentieth century, "pale ale" had become a catchall for all sorts of lighter-colored ales The term was used for the sprightly bright helles in Germany, the milder bitters still served from the cask in English pubs, the especially hoppy creations of American craft brewers, and generic macros in tall cans at supermarkets the world over. It was a level of fame—for better or worse—that no other beer style besides pilsner had attained, or probably will ever attain.

ABOUT THE NAME

There are those, including the great Michael Jackson, who have taken good-natured exception to the use of "pale" to describe beers that often look bronze, brown, or even red. "Pale" describes the clarity of the style, which was revolutionary for beer, not necessarily the color.

TRIVIA

The makers of Sierra Nevada Pale Ale, the most famous and easily found American-made pale ale, were inspired by the old Ballantine India pale ale. Sierra Nevada cofounder Ken Grossman liked the hop-forward citrus taste of Ballantine IPA, so he built a recipe for a brew mimicking it.[53] When

Sierra Nevada Pale Ale was first released in November 1980, it could easily have been called Sierra Nevada IPA, but IPA was seriously on the wane commercially, while pale ale seemed invincible.

HOW TO SAMPLE

GOOD EXAMPLES Go deep and long—there are so many choices. Try, for a start, Sierra Nevada's Pale Ale, Oskar Blues's Dale's Pale Ale, Cisco Brewers's Whale's Tale Pale Ale, SweetWater's 420 Extra Pale Ale, and Deschutes's Mirror Pond Pale Ale.

TEMPERATURE Cool to cold.

LOOK FOR Pale ale should pour a pellucid color of straw to red, depending on the brewery, with a bubbling, crackling head that often endures past the first few sips, but not much longer. There should be a steady balance of sweet and bitter throughout, with the malt upfront and the hops on the finish, and an ABV ranging from around 4 percent to just north of 7 percent.

THIRD WEEK OF APRIL
THIS WEEK'S STYLE

HELLES

WHY NOW?

Because helles is a lighter beer for a lighter time of year. And because Bavaria's beer purity law, called the Reinheitsgebot, initially took effect in the third week of April more than five centuries ago.

BACKSTORY

Helles was developed in the early 1890s in Munich—then, as now, the capital of beer-mad Bavaria. It was a response to the tsunamic popularity of pilsner, the lighter-colored, lighter-tasting lager invented fifty years prior. Pilsner's rise worried Bavarian brewers, who specialized in a darker, heavier lager called dunkel. That was the everyday beer of Bavaria and they liked it just fine, thank you. But its brewers couldn't

ignore the threat of pilsner, so they set about coming up with a homegrown alternative, as most pilsner producers were from outside Bavaria, if not outside the wider German Empire. (Pilsner was named after the Czech city in which it was born, Pilsen, which was located in the region of Bohemia in the Austrian Empire.) What these brewers came up with was helles. It was much lighter and brighter than dunkel, though to most beer lovers' eyes it probably looked more like English pale ale than Czech pilsner. Still, it would do for the locals.

Helles adhered to the nearly sacrosanct Bavarian tradition of the Reinheitsgebot purity law, which in 1516 decreed that beer be made from barley, hops, and water alone—nothing more. Helles, created 350 years later, was in a way a testament to what skilled brewers could do with the simplest ingredients.

Munich's famed Spaten brewery is believed to have released the first commercially available helles in March 1894 under the trademarked name Helles Lagerbier.[54] A Spaten competitor also based in Munich called Thomas-Bräu dispensed with any pretense the following year and named its own helles "ThomasBräu Pilsner," touting it as "the most complete substitute for bohemian pilsner."[55] That might have been the case, but pilsner still took over the beer world—ironically via Germanic brewers such as Anheuser-Busch, Pabst, and Miller (nee Müller)—and helles

remained a largely Bavarian curiosity until (you guessed it) American craft brewers discovered it and popularized it in the United States.

ABOUT THE NAME

Helles is German for "bright" or "pale," a nod to the light color of the style's brews.

TRIVIA

So distraught and angry were the members of the Association of Munich Breweries about having to mimic pilsner that the trade group in a November 1895 meeting declared that they "had no intention of making any pale lagers in the near future."[56] That included Bavarian-born helles. In the end, though, these and other brewers agreed to disagree, and some kept the style alive.

HOW TO SAMPLE

GOOD EXAMPLES Chances are that if a US craft brewery produces a lighter lager and it's not explicitly labeled a pilsner, it's based on helles. See Cigar City's Hotter Than Helles, von Trapp's Helles Golden Lager, Hill Farmstead's Marie, and Jack's Abby's House Lager. Weihenstephaner Helles is an excellent German example that's widely available in the States.

TEMPERATURE Cool to cold.

LOOK FOR A light mouthfeel and a slight hoppy spiciness, but not too bitter. A good helles should be refreshingly bready and crisp on the finish, much like the pilsner the style was originally trying to compete with. The color is golden to straw, and the ABV ranges from 4 to 6 percent. Helles can be a sessionable beer—that is, a style where you can (nay, must) have more than one or two.

FOURTH WEEK OF APRIL
THIS WEEK'S STYLE

(KÖLSCH)

WHY NOW?

Because lighter beers are refreshing at a time when it's getting warmer outside, and kölsch is one of the lightest beer styles without being watery.

BACKSTORY

There's a misconception that kölsch, like its close German cousin helles, was created in the late nineteenth century to compete with the Czech-born pilsner, a crisp, bright, bubbly style then taking over the beer-drinking world. In reality, kölsch was born in Cologne in the Middle Ages. There are mentions of the distinct Cologne style as far back as the late 1200s. By the end of the following century there was

even a local trade group of breweries in Cologne to promote and protect the style.[57]

The style might, however, have been lost to history had pilsner not muscled its way in the way it did. The rise of that pale lager spurred Cologne brewers to resurrect their own pale ale, and kölsch was one of the lighter-looking ales in existence at the time; it was also especially quenching. So kölsch enjoyed at least a regional comeback in the late 1800s, with a key twist on the original brewing method. This time brewers aged it in colder conditions, rendering it even brighter and lighter. Kölsch from earlier centuries was probably akin to the color of dried honey, but by the nineteenth century it was the color of straw.

It would remain a regional hit until American craft brewers picked up on it at the end of the twentieth century and brought it to a wider audience. An earlier infatuation with kölsch among German immigrants in the nineteenth century had led to an entirely new, distinctly American style—cream ale—and that style, too, would enjoy a renaissance in craft brewers' hands.

ABOUT THE NAME

"Cologne" is *Köln* in German, and *Kölsch* is the name for the local Colognian dialect.

TRIVIA

The brewers of Cologne were so legalistically protective of their local style that the makers of a kölsch imitator in the city of Bonn, about twenty miles down the Rhine River, called it bönnsch to avoid trademark trouble. This could also be interpreted as fellow brewers respecting the craft.

HOW TO SAMPLE

GOOD EXAMPLES A lot of American craft brewers have picked up and run with kölsch as their de facto lighter ale offering. The resulting ales include Harpoon's Summer Beer, Saint Arnold's Fancy Lawnmower, Captain Lawrence's Clearwater, Trillium's Big Sprang, and Almanac's True Kölsch.

TEMPERATURE Cool to cold.

LOOK FOR A color of gold to straw, a fruity aroma and taste, and a foamy head that forms and dissipates fairly quickly. The style should not be too bitter, but is instead rather crisp and refreshing. It will have a heavier mouthfeel than most light-colored beers, with a tangy finish and a lower alcoholic kick of generally no more than 5 percent ABV.

THE BREWPUB IS BORN
HOW TAPROOMS AND RESTAURANTS WITH A BREWERY IN THE BACK CAME TO BE

There's one. There's another. And another! They're every-where—bars and restaurants where the beer is brewed on site in the back and then served in the front. They're brewpubs. Or if there's no restaurant component, they're taprooms. They seem so commonplace that it's easy to assume they've been around forever, but by the 1970s brewpubs in the United States had disappeared and tap-rooms barely existed. Consolidation in the wider brewing industry, where the biggest players bought up the smaller ones and most beer in the US belched forth from giant factories rather than quaint brewhouses, was one reason. Another was the changing drinking habits of Americans. Bottled and, especially, canned beer had replaced draft as the main way most Americans got their lagers and ales, largely because they could drink from these vessels any-where, including at home. People didn't need to go out to get drunk. Finally, local and state regulations made brewpubs

The Harpoon Brewery brewpub in Boston. The modern brewpub movement—where breweries make the beers served on premises—dates from Oregon in the early 1980s. There are now thousands of brewpubs nationwide.

and taprooms all but impossible to open. Governments had long memories and were still spooked by the speakeasies that sprang up during Prohibition in the 1920s, and for them it seemed the fewer drinking establishments, the better.

Then came tax changes in 1976 that made it cheaper to brew, and the legalization of homebrewing in 1978, which fostered a freer exchange of expertise among homebrewers and brewing enthusiasts. The first craft brewing start-

ups appeared as a result, and a culture emerged around beer that was served mostly on draft. But because most craft breweries produced only kegged beer—they didn't bottle and wouldn't start canning on any wide scale until the twenty-first century—they had to compete with the likes of Budweiser and Miller for tap handles at local bars and restaurants. The distribution costs alone were enough to sink some early start-ups. They simply could not afford to take the time to self-distribute, nor could they hope to float a distribution deal financially with a distributor used to dealing with bigger players. Supporting a smaller brewery's few kegs a week wasn't worth it to distributors, who often dropped their smaller clients at a moment's notice.

Change came out of the Pacific Northwest and arrived with a bit of Celtic flair due to Bert Grant, who was born in Scotland, moved to Canada as a child, and ended up in Washington State after stints at Stroh Brewery and the hop grower S. S. Steiner, which was based out of Washington's hop-hospitable Yakima Valley. Grant was big and brassy, with multiple chins beneath an impish grin and owlish glasses. He was partial to bonnets and kilts and was known to brandish a sword to quicken disputes toward a resolution. In 1982, he would seize on recent legal changes

Opposite: Adding the all-crucial hops at the Harpoon Brewery on the South Boston waterfront. The brewery was one of the first on the East Coast to go long and strong on an India pale ale.

at the state and federal levels to open the first new brewpub in America since Prohibition. The federal change that helped lead to this was the legalization of homebrewing. The state change was a 1981 tweak to Washington law that made it acceptable for winemakers of any size to transport their wares for exhibitions, tastings, and the like. The law did not cover beer, but it was close enough for Grant, who incorporated the Yakima Brewing and Malting Company two days before Christmas in 1981. Grant would transport his beer from the back of the City of Yakima's old opera house to the lobby, where Grant's Pub served it up.

Call it one small step for beer, one giant leap for the brewing industry. Grant's piecemeal operation served as the inspiration and template for a whole generation of brewpubs that sprouted in California, including one inside an old camera store in downtown Hayward. There, professional photographer Bill Owens ran sixty-two feet of pipe from the back brewhouse to the small restaurant up front serving basic grub. Owens's Buffalo Bill's Brewery made a killing, revealing the formula that would draw brewers and their backers to the brewpub. "For $130 worth of ingredients, I can make a $2,500 profit," Owens told a journalist in 1987. "A glass of lager—that's all I brew now—costs seven cents. I sell it for a dollar and a half. Compare my profit on a bottle of commercial beer: forty cents."[58]

With returns like that, it was only a matter of time before a new animal erupted from the planning cage: the brewpub chain. A group of investors with roots in Colorado's craft beer industry opened the Rock Bottom Restaurant and Brewery in downtown Denver in late 1991. Annual revenue soon topped $1 million, a relative fortune by craft beer standards of the time. There would be several more Rock Bottoms nationwide by 1995, including in Houston, Minneapolis, and Portland, Oregon. Other chains followed suit, including the Heartland Brewery—the first of which opened in an old kayak store off Manhattan's Union Square in 1995—as well as Gordon Biersch and the appropriately named Hops. These chains followed the fall of state laws prohibiting brewpubs and taprooms, beginning with Washington State in the early 1980s and ending with Montana in 1999. The chains introduced more consumers than ever to craft beer and to a wider variety of beer styles more generally. Rock Bottom's Houston location could seat four hundred at a time.

Brewpubs in the United States would boom through the twenty-first century's early decades. By 2021 there were more than 3,300 brewpubs and more than 3,600 taprooms, according to the Brewers Association.[59] These figures represented sharp increases even from the mid-2010s, and their rise was more than a little ironic given the history of government reticence and resistance to

brewpubs. State and local governments—to say nothing of quasi-government agencies such as airport authorities and business improvement districts—would come to celebrate the addition of brewpubs to their streets and transportation hubs as a sign of economic revival and neighborhood cachet. In one of the more interesting twists in the story of American brewpubs, John Hickenlooper, the primary founder of the Wynkoop brewpub in what was then a seedy part of downtown Denver, would ride the notoriety to become the mayor of Denver and later the governor of Colorado and a US senator.

But perhaps nothing underscored the importance of Bert Grant's brainchild to modern brewing better than the effects of the COVID-19 pandemic. The pandemic led to the sudden shuttering in early 2020 of brewpubs and taprooms nationwide as public health officials sought to control the virus. Hundreds of breweries went out of business or came close to it as a result. They relied on the sales out front of the beers they made in the back.

FIRST WEEK OF MAY
THIS WEEK'S STYLE

KENTUCKY COMMON

WHY NOW?

Because the famed Kentucky Derby is run during the first week of May in the state where the style was born. The sweet, easy-drinking beer is a malty alternative to the de rigueur mint julep found at the Derby.

BACKSTORY

Kentucky common was born in or around Louisville, Kentucky, in the early to mid-nineteenth century. Kentucky at the time was near the edge of the still-unfolding United States. (Abraham Lincoln, from just over the Ohio River in Illinois, was often referred to as a politician from "the West" well into the 1860s.) As such, Kentucky attracted pioneering types, including waves of German

immigrants, and what became Kentucky common likely sprang from their tastes and brewing techniques.

Kentucky common in its earliest form was similar to cream ale, another beer style indigenous to America with corn and other adjuncts featured prominently in the grain bill. The adjuncts were likely a way to neutralize the ill effects of having to use the six-row barley that was abundant in the United States. That barley had a lot more protein than the two-row type more common in Europe, and the high protein count would have left a residual detritus that the yeast couldn't convert during fermentation. Hence the addition of corn, which was low in protein but high in starchy sugars for the yeast to convert.

The German influence also meant that Kentucky common was likely an attempt to mimic kölsch or other lighter-tasting ales from the old country. And it worked: the style, as described contemporaneously and in later research presented in 2015 by Leah Dienes and Darwin "Dibbs" Harting, features a lighter mouthfeel and high carbonation, making it refreshing and easy to drink despite a dark amber color that might suggest otherwise.[60]

Why the dark color? Brewers likely added darker malts to the pre-fermentation mash to adjust the Kentucky water, which was, and is, high in salty-tasting bicarbonate, to the proper chemical balance for good brewing. Darker malts were a go-to for brewers who wanted to tweak water quality,

as the malts could neutralize harder, more mineral-heavy water and make it better for brewing.

The other defining characteristic of Kentucky common, aside from its darker color and lighter taste, was the apparent speed at which brewers could make it. It appears it took just over a week to go from mash to mug. That undoubtedly aided its popularity among tavern and restaurant owners servicing what was then one of America's fastest-growing frontier regions.

Alas, the late nineteenth-century rise of lagers laid waste to this quirky ale. There were a handful of Kentucky common brewers at the time of Prohibition's enactment in 1920, but none made it out alive and the style tumbled into the recesses of history. All of this makes its resurrection in the past decade all the more remarkable. There was not even the thinnest commercial connection between Kentucky common's pre-Prohibition heyday and now. The breweries that started producing it in recent years all did so by piecing together the right recipes and necessary techniques based on a sparse written record. The Great American Beer Festival added Kentucky common to its style categories in 2021.

Some people grumble about the snobbery of American craft beer. How could the bloody Yanks have rescued *so many* beer styles from oblivion? The resurrection of India pale ale should have settled the question—it was dying in its homeland of England when US brewers resuscitated it in the

1990s—but if not, then Kentucky common does. It was pulled from extinction like some zymurgical version of the dinosaurs from *Jurassic Park* and left free to run amok, but with happier results. As with IPA, American brewers, homebrewers, and beer fans did the research, gathered the ingredients, assembled the equipment, and made what were effectively test batches, then they tweaked as necessary to recreate styles that much of the rest of the world had effectively forgotten about or shrugged off.

ABOUT THE NAME

"Common" was a catchall for beers made for, well, common folk; it was meant to be brewed relatively quickly and sold just as cheaply. The "Kentucky" part of the name comes from the commonwealth where the style was born and raised. (Incidentally, "California common" grew up as a synonym for "steam beer" to get around the trademark on that name owned by San Francisco's Anchor brewery.) Kentucky common is also sometimes called "dark cream ale" due to its color and textural similarity to that other homegrown American style.

TRIVIA

A defining characteristic of the original Kentucky common was said to be its sourness—except that purported sourness is likely more myth than reality. There are pre-Prohibition

records of brewers noting a sourness in the end, but only as an unintended byproduct, according to Dienes and Harting. Still, Kentucky being the revered birthplace of bourbon and sour mashing (an oft-used technique to jump-start a fresh batch of that holiest of whiskeys), a myth took hold that Kentucky brewers had followed the lead of Kentucky distillers. Not so. The style does not have to taste sour, though some Kentucky common producers appear to lean into the sour mash connection for marketing purposes.

HOW TO SAMPLE

GOOD EXAMPLES The handful of Kentucky common beers are few and far between, and many hew to the myth of sourness. Try Apocalypse Brew Works's 1912 KY Common, which is brewed in Louisville.

TEMPERATURE Cool to cold.

LOOK FOR You want a bubbly, reddish copper pour with a fizzy, fast-dissipating head. The emphasis here is on sweet, casual drinking with an uncomplicated taste free of much bitterness or alcoholic zing. Mild maltiness (or other sweetness from adjuncts such as corn) is the star. Much like its lighter-colored cousin, cream ale, Kentucky common should go down easy. The alcohol content should be no more than 6 percent ABV.

SECOND WEEK OF MAY
THIS WEEK'S STYLE

(MAIBOCK)

WHY NOW?

Because it's spring, and maibock takes its name from the first full month of the season. It's an esoteric, harder-to-find style that, like the buds on the trees and the bushes, emerges around this time to cheer us up.

BACKSTORY

Maibock is a brighter, drier iteration of the bock style, a style likely born in or around the German town of Einbeck in present-day Lower Saxony in the fourteenth century. Beer from Einbeck had a reputation for a strong potency and a very mild bitterness, sometimes an even sweet-ish taste. The religious reformer Martin Luther gave it what was perhaps its biggest marketing boost in 1521

when he declared it the "best drink one can know," after quaffing some in public ahead of his appearance at the Diet of Worms to defend the tenets of what became Protestantism.[61] (And Luther would know: his friends in seminary had nicknamed him the "king of hops" for his love of beer.)[62]

Bock became religiously entwined in another way too. Given its density and strength, it was a popular beverage in Germanic lands during the long Lenten fast in the forty days ahead of Easter. "Liquid bread" was permissible, even if the real stuff was not.

Maibock is younger than the rest of the bock family and might have been a nineteenth-century answer to the rise of pilsner, but more likely dates from the seventeenth century, when bock was already widely brewed in Bavaria, having migrated there from Einbeck. Brewers in the region that would have so much to do with developing paler lagers would surely have pounced on the opportunity to brew a lighter-colored spin on bock. (Bock and maibock were both born as ales, but a maibock can now be a lager or an ale.) Whatever its exact birth date, maibock brewing was part of the beer calendar by the start of the twentieth century. And by the end of it, craft brewers in the United States were embracing it too.

ABOUT THE NAME

Mai is German for "May." As for *bock*, while it means "billy goat" or "ram" in German, the style name might also have

come from a corruption of the pronunciation of "Einbeck beer" or "beer from Einbeck." Brewers and fans took to simply calling it "beck beer," which eventually became "bock beer." Maibock is also sometimes called "heller bock," described with the German word for "bright."

TRIVIA

The first barrels of maibock in Bavaria have traditionally been tapped on May 1, corresponding with May Day in much of Europe.

HOW TO SAMPLE

GOOD EXAMPLES Maibocks abound internationally and domestically in April and May, and include Jack's Abby's Maibock Hurts Like Helles, Ayinger's Maibock, Rogue's Dead Guy Ale, Lakefront's Maibock, and Hofbräu's Maibock.

TEMPERATURE Cool to cold.

LOOK FOR An amber to golden color with a fluffy, lasting head; malty sweetness upfront and a sweet dryness on the finish with lingering bitterness; a dense and chewy mouth-feel; and an ABV between 6 and 8 percent. Altogether this makes for a perfect spring beer.

THIRD WEEK OF MAY
THIS WEEK'S STYLE

MILD

WHY NOW?

Because there's an annual campaign called "Make May a Mild Month" meant to celebrate and preserve the style. And the style still needs rescuing, as it's long struggled for relevance against stronger, heavier beers.

BACKSTORY

By the 1930s, mild beer is believed to have accounted for as much as one-third of the beer brewed in its native United Kingdom, and it was well on its way to becoming the de facto national style of the UK—then and now, one of the world's great beer nations. The mild classification had over the previous century come to describe a style of beer noted for its exceptional maltiness, lack of bitterness, and relatively low

alcohol content. It was what American beer geeks would later describe as a true session beer: that is, one you can down several of without becoming too inebriated. And this fact perhaps more than any other ensured the style's international appeal. People apparently took to a style that wouldn't leave them too drunk. It turned up in force in British-infused areas such as Canada, South Africa, and New Zealand, and also appealed to American and continental palates.

So what happened to this dominance and belted "porter's sweeter, gentler young brother" from its throne?[63] A cruel fate befell mild: war. The British government during World Wars I and II encouraged the country's brewers to produce weaker beers to save on foodstuffs and material as well as to keep the workforce and potential soldiery soberer. Unfairly, the mild style became associated with this watery, weak beer. Given that pubs were the main source of mild, changing drinking habits and beer packaging after World War II stymied the style as well. People were just as content to stay home and drink one of the newfangled mass-produced pilsners and other lighter lagers sold in cans at the grocery store. Sales of mild suffered as a result, and production declined.

What's more, the mild still in the kegs lacked the alcoholic strength and hops content to steel it against spoilage. One too many poor-quality pints turned off drinkers, especially younger ones, who associated mild

with their parents' or grandparents' generations. Mild in the mid-twentieth century, then, entered what still looks like a terminal decline. Even the interest of American craft brewers and consumers toward the end of the century did not seem to resurrect its popularity—at least not to anywhere near where it was a hundred years ago.

ABOUT THE NAME

Today "mild" is used as an adjective and indicates a sweeter, less hoppier counterpoint to bitter beer, the other English pub staple. However, "mild" might have emerged first as a descriptor for fresh beer. In an era when most beer was served by draft rather than by can or bottle, "mild" may have indicated a beer was young, or more recently produced, and therefore less likely to have spoiled in a keg or cask. (Bottled and canned beers keep fresher longer due to their seals.) This theory is bolstered by the fact that many early milds had high alcoholic kicks of up to around 6 percent ABV. A beer with a high ABV wouldn't naturally be referred to as mild, unless the word was referring to a different feature; say, its age rather than its strength.

TRIVIA

In 1976 the Essex chapter of the United Kingdom's Campaign for Real Ale (CAMRA) promoted a "Make May a Mild Month" campaign to keep the style alive. CAMRA, which seeks to bolster the British brewing industry, took up the cause nationally the following year.[64]

HOW TO SAMPLE

GOOD EXAMPLES Given the popularity of stronger, heavier beer styles, good examples of mild can be difficult to come by outside of a British public house. Search out Yards's Brawler (from Philly) or Theakston's Dark Mild (from across the pond). Small Change Beer Company out of Somerville, Massachusetts, also produces an excellent example. May more such examples arise!

TEMPERATURE Room to cool.

LOOK FOR Deep red to brown color with a buoyant, lasting head and plenty of lace on the glass. There should be a fruity sweetness upfront followed by a rich, chewy finish with just the slightest hint of bitterness, and, of course, a low alcohol content; there's no more than 4 percent ABV in a genuine mild.

FOURTH WEEK OF MAY
THIS WEEK'S STYLE

PILSNER

WHY NOW?

Because the exceptionally light and refreshing style is a perfect summer beer for Memorial Day cookouts.

BACKSTORY

The world's most popular beer style was developed in the early hours of October 5, 1842, when brewmaster Josef Groll and assistant brewer Jan Eisner began brewing the first beer for the new Burghers' Brewery in Pilsen, a midsize city in the Austrian Empire's province of Bohemia. The beer would be tapped in at least three pubs and inns in Pilsen on the feast of Saint Martin of Tours on Friday, November 11, 1842, and it would prove to be a sensation almost from the get-go.

Pilsner Urquell is the original pilsner, dating from the 1840s in the present-day Czech Republic.

No one had previously seen such a brilliantly golden beer. Beer for millennia had been on the darker side—not necessarily dark brown to black, as with porter or stout, but at least bronze to reddish—and the golden clear color was an entirely new phenomenon.

Here's how it happened. The leaders of Pilsen (called "burghers") who had the right to brew within the city had become annoyed by Bavarian imports. Pilseners were buying more foreign dunkel and märzen, and less Pilsen-produced

beer. Local beer was consequently sitting in kegs longer and invariably degrading, even spoiling. In fact, so poor was the quality of the local brew that on at least one occasion, in February 1838, citizens dumped dozens of barrels of local beer in front of the city hall. The following year, the burghers issued a public manifesto stating their plan to erect the most modern brewery Pilsen had ever seen in order to make beer with Bavarian techniques and ingredients. And it would be made by Bavarians themselves.

Groll, like his three immediate successors as brew-master, hailed from Bavaria. A moody, gruff, mad-genius type, he had likely accrued all of the latest brewing skills, including how to roast malts just so and how to filter wort to achieve clearer, cleaner beers. Groll's skills and techniques would help this new Pilsen brewery craft a beer to compete with Bavarian imports. Those imports were dark, though not opaque, and while hearty, they were not particularly thick or rich like English ales. So Groll pursued a lighter, thinner concoction and came up with a knockout.

The roasting techniques explained the golden color. The crispness and lighter taste came from the soft water around Pilsen and the Bavarian yeast. The hops were from Bohemia. It all came together at a point in time when beer was already trending toward lighter colors and tastes. Lagers were on the ascent and ales were beginning a century-long fade, at least outside the United Kingdom and tiny Belgium. A golden

lager was probably inevitable. Groll's creation for the Burghers' Brewery in Pilsen would do.

Pilsen's golden child was being served in Prague, two days' travel away, before the end of its natal year, 1842, and had made its way to the imperial capital in Vienna by 1856. It was only a few years later that the Burghers' Brewery registered a regional trademark on the style, but by then it was too late. There were already imitators throughout Bohemia and even into what became Germany.

The mass emigration of hundreds of thousands of Czechs and Germans to the United States in the late 1840s and throughout the 1850s would tee up the style to dominate the beer world. German-American outfits such as Pabst, Anheuser-Busch, and Miller leaned on pilsner for their most popular offerings. As for Josef Groll, his acerbic personality likely caught up with him, and in 1845 the burghers parted ways with their brewmaster. Groll then returned to Bavaria to run a brewery he inherited from his father, and died in 1887 at the regulars' table of his favorite pub.[65]

ABOUT THE NAME

The German word *pilsner* roughly translates to "beer from Pilsen."

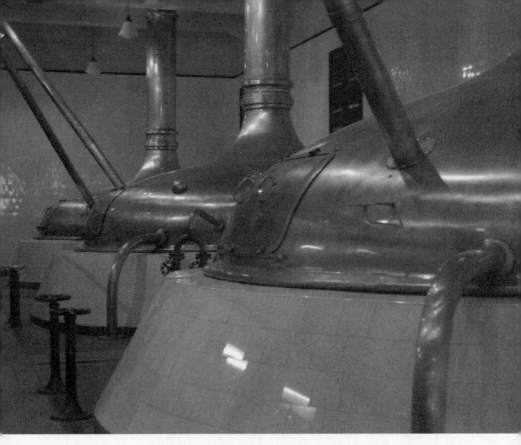

Pilsner Urquell is still made in the same location in Pilsen in the Czech Republic. Here is a model of the older, nineteenth and early-twentieth century brewhouse. Most of the lager is produced in more modern facilities on the site.

TRIVIA

On February 8, 1898, the Burghers' Brewery trademarked Pilsner Urquell—"genuine pilsner"—with the national authorities in Vienna. However, it was too late to stop knockoffs. Visitors today can still tour the original brewery in Pilsen, the only source of the original Pilsner Urquell.

HOW TO SAMPLE

GOOD EXAMPLES Because pilsner is the world's most popular beer style, examples abound, from the cheaply mass-produced to the more expensive, small-batch iterations from craft brewers. This range includes Pilsner Urquell, Budweiser, Pabst Blue Ribbon, Victory's Prima Pils, Oskar Blues's Mama's Little Yella Pils, and Sierra Nevada's Nooner.

TEMPERATURE Cold.

LOOK FOR A brilliantly bright pour with a lot of carbonation and, depending on the quality of the specific pilsner, either a thin, quickly dissipating head or a fluffier, sturdier one. It should be crisp, dry, and slightly bitter, finishing with a bready, cereal-like sweetness. The ABV runs between 4 and 7 percent.

BEER IN SUMMER

"I would want a Bavarian wheat beer to quench my thirst on a hot day, a Bohemian lager to accompany the fish I would catch on my desert island, a British ale to go with the wild animals I would barbecue, and a barley wine to intoxicate me when I longed for escape."[66]
—MICHAEL JACKSON

Jackson was writing for the United Kingdom's *Independent* newspaper in 1993 about beers he'd want if stranded on a desert island and hit on the biggest reason for drinking beer in summertime: its refreshing nature. The styles of summer are lighter in appearance and less filling, making them especially palatable in the heat and humidity.

That lightness used to exclude complexity. Lighter beers—never mind light beer in and of itself—had often been considered bland and straightforward. People did not drink them for the palatal discoveries. Not anymore. The fact that

Opposite: The exterior of the Westmalle monastery, which hosts one of only eleven Trappist breweries. It's located in a bucolic area of Belgium, which hosts a majority of such operations. To be designated Trappist, the brewery must be located within the monastery's grounds, among other conditions.

Jackson cited "a Bavarian wheat beer" as an afficionado's desert-island brew gets at the reason: the most quenching of beer styles no longer means watery. They can now rank in complexity alongside the barley wines of winter.

FIRST WEEK OF JUNE
THIS WEEK'S STYLE

MEXICAN LAGER

WHY NOW?

Because Mexican lager is the perfect sessionable beer for sipping in the heat. We're getting to the middle of the year too, and Mexican lager proves that even six months in there's something new and novel to try.

BACKSTORY

While people have been making beer (or at least fermenting grain or corn into alcohol) in what's now Mexico for thousands of years, and certainly since the exploitative European conquistadors arrived in the sixteenth century, a modern brewing industry did not take hold in Mexico until the 1800s.[67] As in the United States, when modern brewing

finally arrived, it was due to an influx of Germanic Europeans. In Mexico's case, this influx resulted from an ill-conceived, inept, and brutal attempt by the French emperor Napoleon III (not *the* Napoleon, his nephew) to install a puppet regime in Mexico City. To legitimize it, Napoleon III selected Maximilian of Habsburg, an Austrian archduke and the younger brother of Austria's emperor, and he came from Vienna in 1864 to accept the crown. There had been a trickle of Germanic immigration to Mexico prior to Maximilian, but it sped up after his coronation. (His wife, incidentally, was a princess from Belgium, another of the great brewing nations.)

Maximilian's regime lasted barely three years, in part because after the American Civil War ended in 1865, America was none too pleased to have a European coup on its border. The result was that the United States provided support to the Mexican rebels protesting European rule, and ultimately the ersatz emperor found himself pressed against a wall by Mexican rebels and shot.

Was Maximilian's roughly thirty-six months in power enough time to spread much of anything Austrian, including brewing techniques? Probably not. Beer was not a commercial concern in Mexico in the way it was in the United States. The latest insights into ingredients and brewing techniques, such as new ways of roasting, were not in great demand. Besides, Maximilian never totally controlled a majority of the country. But a relatively large number of Austrians and

Germans did come over during and in the years after his reign, and it's likely that they brought with them a taste and tool kit for European styles such as Vienna lager, pilsner, and dunkel.

By the 1890s there were several breweries in Mexico producing pilsners and Vienna lagers on a large scale.[68] As in the United States, German brewing techniques and ingredients overtook a lot of breweries, and people of German descent owned and operated the breweries. All of the breakout Mexican brands, such as Corona, Dos Equis, and Modelo, were interpretations of Vienna lager and (especially) pilsner. So they weren't particularly new, but they were locally made—a meaningful trait, in much the same way that Budweiser and Pabst Blue Ribbon didn't represent a radically new direction for pilsner in the US, but were noteworthy to Americans because they were locally made.

Where, then, was Mexican lager born, and where did it grow up? Beer guides for the United States and Mexico as late as the mid-2010s don't even mention the style. Or they mention lager from Mexico, but not necessarily a distinct style called "Mexican lager." Michael Jackson never used the term (and reserved a particular enmity for Corona besides), and the Great American Beer Festival still doesn't have a judging category for it, though Mexican lagers have medaled in other categories. Despite its name and Mexican

origins, it appears that Mexican lager actually became a distinct style in the United States. American craft brewers, including those of Mexican descent, borrowed from the likes of Corona to create a style noted for its sweetness— the use of adjuncts such as corn is celebrated—and its lack of a sharp bitterness. By the start of the 2020s, most beers calling themselves "Mexican lager" were made in the United States (in much the same way as the world's best-selling Vienna lager, Samuel Adams, is made outside Austria).[69]

ABOUT THE NAME

Lagers made in Mexico by Mexican breweries proved enduringly popular, but the term "Mexican lager" seems to have originated north of the border. Call it a particularly annoying example of cultural appropriation, or a triumph of marketing.

TRIVIA

The earliest Mexican lager in the United States was likely Ska's Mexican Logger. The Durango, Colorado-based brewery released it on draft in 1999, calling it "Mexican-style lager." As for who brought macro-scale lager brewing to Mexico, it wasn't a German or an Austrian; it was a Swiss named Bernhard Bolgard who was brewing in Mexico City in 1845.[70]

HOW TO SAMPLE

GOOD EXAMPLES There are a lot more to choose from today than there were just a few years ago. Look up Ska's Mexican Logger, pFriem's Mexican Lager, Stone's Buenaveza, Lone Tree's Mexican Lager, and Atrevida's Dolores Huerta. There are also the uber-macro Mexican lagers Corona, Pacifico, and Dos Equis.

TEMPERATURE Cold.

LOOK FOR A bright, bubbly pour with a thick but rapidly dissolving head. The effervescent pour leaves behind a thin, refreshing body with a lemony, grainy sweetness and little to no bitterness on the finish. The ABV is between 4 and 7 percent.

SECOND WEEK OF JUNE
THIS WEEK'S STYLE

GOSE

WHY NOW?

Because this famously salty and sour beer style is a perfectly acidic thirst-quencher that pairs well with summer luxuries like blueberries, lobster, and freshly caught fish. Outdoorsy people in particular tend to love it.

BACKSTORY

The roots of gose might be thousands of years old, but the style is most closely associated with the form it evolved into in the seventeenth or eighteenth century in the town of Goslar, between Hanover and Leipzig in today's north-central Germany. There, brewers first crafted the modern version of the style using water from the nearby River Gose (until indus-trialization in the 1800s, brewers always used the local

water, unfiltered), which gave the beer a distinctive saline taste and aftertaste. The sourness came from the bacteria that zigs and zags all around us in the air. Until the late 1800s, brewers didn't really understand how bacteria might affect their brews. Today, modern brewing often controls mercilessly for bacteria, trying with exacting technology and techniques to keep it out of the brewing process lest it spoil the beer. Lucky for those in and around nineteenth-century Goslar, that was not the case, and rather than spoiling the beer, the bacteria helped provide a unique taste. (Indeed, a mastery of bacteria allows modern-day brewers to add it as they see fit to make today's sour beers.) Brewers embraced the sourness back then, leaving their fermentation vats wide open to draw the bacteria—a true local ingredient, if you think about it (though the same bacteria might've been found elsewhere beyond Goslar and its immediate region).

Maybe unsurprisingly, the salty, sour beer didn't make it far beyond Greater Leipzig or Greater Hanover—at least not until the twenty-first century, when craft beer geeks who like to bike and hike resurrected it.

ABOUT THE NAME

We know where it came from. But pronouncing "gose" is another matter if you're not a German speaker. No, it's not gose as in "goes." It's gose as in "go-sah." Purse your lips

and slowly pronounce "rosa." Then sub out the "ro" for "go" and you're all set.

TRIVIA

Since 2016, gose brewers and aficionados in Leipzig have marked November 17 as International Happy Gose Day to celebrate the style. While this provides a good reason to enjoy the beer in the fall, gose is still better served in warmer months given how thirst-quenching it is.

HOW TO SAMPLE

GOOD EXAMPLES South Carolina's Westbrook produces what is probably the most widely available gose in the United States. Connecticut's Two Roads also offers gose selections, usually with undertones of dark fruit.

TEMPERATURE Gose is one of the few beer styles that is best drunk at room temperature.

LOOK FOR Don't expect a thick, lasting head in gose. Its bubbles evaporate quickly, though it should still taste bubbly. Look for sourness and that bracingly refreshing acidity from the saltiness. It shouldn't be too strong, no greater than 5 percent ABV, and will finish exceedingly cleanly.

GOLDEN ALE

WHY NOW?

Because as we're ramping up to the hottest, brightest, and longest days of the year with the summer solstice on June 21, why not enjoy a style that is defined by a hue often likened to sunshine and, well, gold? Plus, it's a refreshing style to enjoy in the increasing summer heat.

BACKGROUND

There's a specific birthday for golden *lager* (a.k.a. pilsner): November 11, 1842, when the first kegs of pilsner were tapped in Pilsen, which today is part of Czechia. Golden *ale*, on the other hand, emerged over time from the brewing innovations of the eighteenth and nineteenth centuries to

become a kind of all-encompassing term for the brightest ales brewers could produce.

Belgian golden ale, the likely predecessor to golden ale as we know it today, dates from the late 1800s and early 1900s.[71] It's theorized that as the Germans were pumping out kölsch and helles and the Americans were tinkering their way to what would become cream ale, both to compete with the Czech-made pilsner storming the beer market in the nineteenth century, Belgian brewers were crafting their famed ales to be that much more brilliant, also to compete with pilsner.

In the late 1970s, Michael Jackson may have been the first to coin the style name in English to categorize the brightly hued Belgian ales, such as Duvel, that would give rise to the more general style that we today call golden ale. The style—a crisp, bright, bubbly pour—would become a favorite plaything of craft brewers in the 1990s, with a rediscovery of the Belgian originals.

ABOUT THE NAME

Golden ale also goes by "blonde ale." In fact, blonde ale might be the more common term given the sheer number of puns and innuendos that American brewers use in their marketing and packaging materials, some of which are quite sexist and tasteless.

Opposite: A golden ale, such as Duvel, should pour bright and, well, golden, with a sustained, foamy head

TRIVIA

Duvel from the Duvel Moortgat Brewery (originally the Moortgat Brewery) in Belgium's Flanders is perhaps the prototypical golden ale, both in its characteristics and its commercial reach. Until it was created in 1970, the brewery had produced mostly darker ales. Duvel would change that.

The Duvel name supposedly came from a Moortgat worker declaring, "This is a devil of a beer!" upon testing a batch. *Duvel* means "devil" in Flemish and Dutch. According to Michael Jackson, Moortgat introduced Duvel to compete with the lighter-colored beers from fellow Belgian outfit Stella Artois.[72]

HOW TO SAMPLE

GOOD EXAMPLES Duvel Moortgat's Duvel is widely available in the States. As for domestic brews, look for 49th State's Blonde Eagle Ale, NOLA's Blonde Ale, Narragansett's Fresh Catch, Kona's Big Wave, Lord Hobo's Freebird, and Leffe's Blonde.

TEMPERATURE Cool to cold.

LOOK FOR A bubbly, swirly pour crackling with carbonation that ends in a pillowy head that hardly dissipates; a golden to blonde color; and a sweet, malty mouthfeel with a crisp, slightly bitter finish. This airy style is dangerously drinkable, with ABVs that can range from just above 3 percent to around 7 percent.

FOURTH WEEK OF JUNE
THIS WEEK'S STYLE

$$\boxed{\text{FRAMBOISE}}$$

WHY NOW?

Because raspberry harvesting is in full swing all over the country and framboise, named after the French word for "raspberry," is one of a few great fruit-flavored styles to try.

BACKSTORY

If kriek is the most popular fruit-infused lambic style, framboise runs a close second. As with its cherry kin, it's unknown today who first decided to use raspberries to flavor lambic, but it was a distinct style within the Belgian region of Pajottenland by the end of the nineteenth century. At the time, before the wide use of artificial refrigeration, lambic brewing—indeed, most brewing—was done in the colder months to help quickly cool the open vats of wort

awaiting fermentation from the wild yeast. Left open and exposed too long in warmer heat, the wort would never cool fast enough and would become infected with all manner of bacteria.

Also, raspberries and cherries, like most fruit, tend to ripen in the summer, so harvesting in time for a fall brew made sense. With traditional framboise and kriek, the fruits are added in the cask or keg. By this point the wild yeast has largely exhausted itself, but usually has a little strength left to power the secondary fermentation using the sugars of the fruit.

Framboise would have remained an esoteric appendage of the grand Belgian brewing tradition had it not been for the research and writing of Michael Jackson beginning in the 1970s. The style was at a commercial dead end, perhaps even on the precipice of extinction, with a number of producers so small it could have been counted on two hands by the time Jackson took up the cause.

Today more breweries both in and outside of Pajottenland are making framboise (the ones outside give purists pause). The popularity of framboise has also led brewers to produce other fruity beers, including pêche (peach) and cassis (black currant), though none have the long history of framboise or kriek.

ABOUT THE NAME

Framboise means "raspberry" in French. You'll also some-times see the Flemish word for raspberries, *frambozen*, used to refer to the style.

TRIVIA

There is also an eau-de-vie (a fruit brandy) called framboise. It's made from distilled raspberries. Don't confuse the two if you're ordering in France or Belgium.

HOW TO SAMPLE

GOOD EXAMPLES The best examples are invariably going to be imports like Lindemans's Framboise, 3 Fonteinen's Framboos, and Cantillon's Lou Pepe Framboise.

TEMPERATURE Cool to cold.

LOOK FOR A bubbly, red pour with a sparkly, foamy head that dissipates quickly; a dryness on the front and the back that's so pronounced you could towel off with it; and a bouquet of sharply tart raspberry throughout with very little bitterness. The ABV should be no more than 5 percent.

CAN DO
A HISTORY OF BEER PACKAGING

Craft beer was born in kegs and casks, and grew up in bottles. In the 1970s and 1980s, start-up breweries throughout the United States packaged their beers in glass or stainless steel—never in cans. Craft brewers and critics considered cans the low-rent domain of macrobrewers. They were what your uncles cracked open in their recliners and downed in a few grimacing gulps before crushing the can, tossing it, and cracking open another. Besides, there were no affordable canning systems available to smaller brewers. The cheapest systems by the 1990s might have started at $250,000, not including maintenance. Given the preference for bottles in the craft beer community, it was better to go with a bottling line of comparable cost.

Things began to change in the 1990s. The Mid-Coast Brewing Company of Oshkosh, Wisconsin, contracted to have its craft lager brewed and canned at a larger brewery

Opposite: A modern craft beer canning line, this one at Rogue Ales & Spirits in Oregon. The first canned craft beers appeared in the early 1990s, and were not well-received. Within twenty years, though, canned craft beers began to overtake bottled ones in terms of sales.

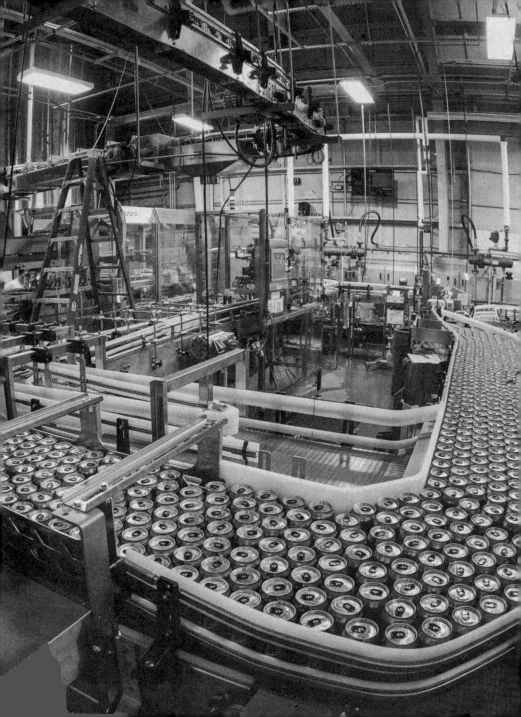

about an hour's drive away. In June 1991, it released its Chief Oshkosh Red Lager in a can and the reaction caused a minor ripple in the beer world. The fuss was short-lived, however, as the canned lager ceased production when Mid-Coast Brewing closed its doors a few years later.

After this, there were intermittent attempts by contract brewers—craft brewers that did not have their own physical breweries but instead rented the labor and facilities of larger breweries—to can some of their offerings. The most notable were those of Boston Beer (maker of Samuel Adams), which contracted to have its cream ale canned for the UK market, and Pete's Brewing Company (maker of Pete's Wicked Ale), which contracted to have some of its Wicked Summer Brew canned for US consumers.

In 1999 Cask Brewing Systems of Calgary, Alberta, in Canada, introduced a manual canning system. For a paltry $10,000, a brewer could can two twelve-ounce beers at a time in a space no bigger than a tabletop. It was a way over the price hurdle. But the perception hurdle remained. Cask Brewing's attempts to sell its system, originally designed to satisfy a short-lived fad that had customers brewing their own beers at shops, crashed against craft brewers' skepticism of cans. "Nobody will put their craft beer into aluminum cans," one attendee at the 2002 Craft Brewers Conference told company reps.[73]

Enter Oskar Blues. The Lyons, Colorado, brewpub's founder, Dale Katechis, bought a Cask Brewing System canner and started canning its hoppy Dale's Pale Ale two at a time in a nearby barn. The first cans debuted in the fall of 2002, and within a few years several other breweries followed. Soon, young craft breweries began introducing their first beers in cans, rather than bottles—including sixteen-ounce tallboys, once the purview of super-cheap malt liquor or light macro lagers.

Still, glass would remain the preferred packaging choice for most brewers. Cans would not crest 10 percent of packaged volume until 2015, and bottles were still in greater use into the 2020s. But the move by Katechis and company in 2002 had shredded the negative perception of cans. Indeed, progenitors of the New England India pale ale—that super-hazy, super-bitter style born about ten years after those first cans of Dale's Pale Ale—advised drinkers to imbibe right from the can itself so as to absorb as much hoppy aroma and foretaste as possible. Pouring it out would only dissipate the intensity.

Craft breweries came around to cans in much the same way as bigger breweries had come to glass bottles a century before. Until the twentieth century, most drinkers had taken their beer in an open container, such as a mug, stein, glass, or jug. The finished product often trav-

eled from the fermentation vessel to a keg or cask, perhaps having been filtered in between, before it was poured into the open drinking container. Packaging in sealed individual containers, almost always bottles, came along in fits and starts, but wasn't common practice until the late 1800s.

The brewery that put the entire industry over the hump from draft to bottles was Anheuser-Busch. Larger breweries such as Bass and Guinness had been bottling beer for longer, but the St. Louis-based Anheuser-Busch took it to a new level. The company, founded by Eberhard Anheuser and his son-in-law, Adolphus Busch, both German-Americans, did three things that set it on a path to creating the largest bottling plant in the United States by the end of the 1870s. First, Anheuser-Busch bottled in-house rather than contracting out the process. Second, the company leaned into steam-powered auto-mation rather than bottling by hand, which had been the common practice. And third, Anheuser-Busch used new developments such as pasteurization and artificial re-frigeration to gird their bottled beers—including Budweiser, introduced in 1876—for longer journeys.

Competitors such as Pabst and Miller soon brought in vast bottling lines in huge, cacophonous factories, and bottled beer spread farther than ever before. Still, most beer in the United States as late as the 1930s was draft. Consumers

went to bars and restaurants, ballparks, and theaters to wet their whistles.

On the second-to-last Thursday in January 1934, the Gottfried Krueger Brewing Company of Newark, New Jersey, rolled out the first canned beers. The canning utilized technology that had been decades in the making, as it had been repeatedly improved on by Krueger and its supplier, the American Can Company, to prevent beer from being tainted by the can's metal lining and address other problems. Anxious about whether consumers would take to the new packaging, Krueger sold its first cans in Virginia, a ways away from its New Jersey base. The company also slapped "Same as Bottle" on the cans to reassure drinkers of the contents' taste and texture. After this initial launch, canned beer, like bottled beer sixty years prior, began to spread.

In 1941 packaged beer, whether bottled or canned, outsold draft beer for the first time in the United States. The moment marked a larger shift: never again would Americans consume most of their beer outside the home; the beverage became a staple of living rooms, kitchens, patios, and garages more than bars, restaurants, and ballparks. By 1970 canned beer would outsell bottled in the United States, and was well on its way to gaining favor abroad as well.

FIRST WEEK OF JULY
THIS WEEK'S STYLE

NEW ENGLAND INDIA PALE ALE

WHY NOW?

Because it's the Fourth of July and the opening shots of the American Revolution rang out in New England. This style, defined by its haziness, is perfect for hot summer nights in the drift of smoke from fireworks and bonfires.

BACKSTORY

Much like the style itself, the origin of New England India pale ale is murky. It is an offshoot of India pale ale, which came out of nineteenth-century England and was noted for its bitterness in comparison to what would now be considered especially mild pale ale. IPA as a style survived into the late twentieth century, but appeared to be in terminal decline on both sides of the Atlantic until American craft brewers

made the style their own and led it to become the most popular craft beer style.

Early American IPAs were especially aromatic and bitter, and some were hazy. Ken Grossman, cofounder of Sierra Nevada Brewing and the driving force behind the growth of IPA, noted in his book about the brewery's early days that there were "some pretty hazy beers" dating back to the early 1980s.[74] These early American IPAs don't appear to have had much of a shelf life in terms of their commercial appeal, but the bitterness they introduced would have a long shelf life, as it turned out. By the early 1990s, IPAs like Sierra Nevada's pale ale (an IPA in all but name) were noted for their exceptional bitterness.

It was the West Coast brewer Vinnie Cilurzo who invented the super-hoppy double IPA style in 1994. Cilurzo was crafting an IPA for his new brewpub, the Blind Pig, and worried that off-flavors might make it through, so he used generous helpings of hops to cover any off notes. East Coast brewers such as Dogfish Head, out of Delaware, would soon take up the same strategy, and even brag about using copious amounts of hops at nearly every stage of brewing, usually for the sheer bitterness they would produce and the sharpness they would bring to the taste. All of these breweries prized clarity in their final products, though, whatever the volume of hops—and consumers expected it, as clarity had been the way of things with nearly every

beer style, including IPA, since the rise of the modern science of brewing in the mid-1800s. A clean-looking beer, however aromatic or bitter, was a sign of skill.

Or it *was* a sign of skill until the early 2000s, when exceptionally hazy beers started pouring forth from northern New England. The first commercially successful one—sold as a deliberately hazy IPA—was Heady Topper from the Alchemist brewpub in Waterbury, Vermont.[75] Alchemist's brewer and co-owner, John Kimmich (his wife, Jen, ran the business side), first brewed what became Heady Topper in January 2004. It was available on draft through the end of the decade, when the couple responded to deafening demand and started canning it in 2011 (just as a tropical storm wiped out their brewpub).

Kimmich had worked in the mid-1990s for Greg Noonan, the legendary founder of the Vermont Pub and Brewery in Burlington, the oldest brewpub in the Green Mountain State, and Noonan had encouraged Kimmich to push the style boundaries of the reemerging IPA style. In response, Kimmich leaned into dry hopping—the addition of more hops toward the end of the brewing process—and ended up with some hazy IPAs. He would later say that it had never been his intent to deliberately create a hazy beer; instead, he was experimenting with new approaches to

Opposite: The Alchemist Brewery's equipment churns away under the gaze of a Vermont autumn. The brewery pioneered what came to be known as the New England India pale ale style.

what was fast becoming a popular style again.[76] At Alchemist, Kimmich would take those initial results from the mid-1990s and improve on them.

The Kimmiches called John's Heady Topper an American double IPA, the style they and so many other smaller breweries were chasing at the time. They never called it, or intended for it to be called, a New England IPA. But in their quest for bitterness Heady Topper was made with plenty of dry hopping and served unfiltered, resulting in a persistently cloudy beer with a look reminiscent of grocery store orange juice. The haziness was a byproduct, not the end goal, but no matter—a new style was born.

Other American brewers might have made similarly hazy IPAs and double IPAs going back forty years, but none had put one forth commercially as such. By the end of the 2000s, New England IPA was firmly entrenched both as a style and as a cultural touchstone for beer fans. Some dismiss it still as a lucky—and overly fussy—fad that stuck, while others embrace it as a welcome new style.

ABOUT THE NAME

Early fans of the Alchemist's Heady Topper wanted the Kimmiches to call it "Vermont India pale ale," but John dismissed that as false marketing, as if such a style could only be made in Vermont. A regional designation would stick,

however, driven by how many New England breweries were trying their hands at the style. The style also goes by the names "hazy IPA" and "juicy IPA," and might also be called "New England double IPA" or "hazy pale ale."

TRIVIA

What exactly did John Kimmich set out to do in January 2004? Make "beer that tasted like great weed—that was pretty much the goal with Heady Topper," he told the journalist Michael Kiser in 2016. With its often sharp, floral scent and its inebriating effects, marijuana has long been a muse for American craft brewers. It's in part gustatory: *Humulus l upulus* (hops) and *Cannabis sativa* (marijuana) are from the same plant family.[77]

HOW TO SAMPLE

GOOD EXAMPLES Samuel Adams's Wicked Hazy, Firestone Walker's Mind Haze, and Sierra Nevada's Hazy Little Thing are solid examples that are widely available nationally. Harder-to-find examples include Alchemist's Heady Topper and Haze from the Massachusetts-based brewery Tree House.

TEMPERATURE Cool to cold.

LOOK FOR An explosion of foamy, bubbly bright orange or yellow that doesn't clear even as a thick head rapidly forms, and engulfing notes of floral citrus at the start and a pushy bitterness throughout that should end a little on the mildly dry side (but often doesn't). There is very little malt backbone, but that's not what the style's about. Instead, it's about bitterness, despite whatever its brewers might say about balance. And that's the biggest knock that critics of New England IPA wield against the style: its over-the-top sharpness. ABVs run from 7 percent to just shy of 10 percent.

SECOND WEEK OF JULY
THIS WEEK'S STYLE

(BIÈRE DE GARDE)

WHY NOW?

Because bière de garde is a definitive French style and Bastille Day, celebrated in France on July 14, commemorates the French Revolution.

BACKSTORY

Yes, French beer. The country most associated with wine and wine culture boasts some exceptionally good and important beer. It was also the home of perhaps the most influential figure in modern brewing: Louis Pasteur. Pasteur's research in the mid-nineteenth century into yeast's role in brewing and how to keep beer from spoiling essentially elevated brewing from an art to a science. Pasteurization—basically using

heat to kill bacteria—unlocked many a brewery's potential for packaging and shipping beer.

Pasteur would have been familiar with bière de garde, which developed in northeastern France near beer-mad Belgium, though other details of its first emergence are no longer known. Bière de garde falls under a charming stylistic umbrella called "farmhouse ale," which also includes saison from over the border in Belgium. Farmhouse ales are rudimentary yet tasty ales that originated in agricultural communities in the band of Europe located from northwest of Paris to northwest of Brussels and stretching from these areas to the English Channel. These were beers for personal consumption and not necessarily for commercial sale.

By the nineteenth century—Pasteur's lifetime—bière de garde was a distinct, though still evolving, style. Early accounts describe its taste as sour and—this being France—vinous.[78] The modern form of it dates from the 1920s, when the Brasserie Duyck in Jenlain released a bière de garde named after the town. The fruity, malt-forward ale with hints of vanilla and black licorice became the standard by which others measured the style.[79]

Bière de garde remains intimately associated with French beer, and zymurgical gourmands swear they can taste the subtle differences between it and Belgium's saison.

The latter became much more popular in the United States among craft brewers, as did Belgian beer generally. This led to bière de garde's status today as a rewarding but hard-to-find style (even in parts of France).

ABOUT THE NAME

Bière de garde conveys "lager beer." A more exact extrapolation might be "beer for keeping," a reference to the era before artificial refrigeration, when people would brew during the cooler months and store (or lager) their creations for drinking in warmer months. Incidentally, some bières de garde are now brewed with lager yeast and, interestingly given their French heritage shared by Louis Pasteur, are generally unpasteurized. This harkens to their rustic roots.

TRIVIA

Aggression from Germany, one of the great beer nations, drove some of Pasteur's research. The Germans had taken the French regions of Alsace and Lorraine in the Franco-Prussian War of 1870—including the regions' hop fields—and Pasteur wished for French brewers to produce what he described as "beer of revenge."

"I was inspired to do this research by our misfortunes," Pasteur explained at the time about his brewing-related work. "I began working on it immediately after the War

of 1870 and have ceaselessly pursued it since that time, determined to carry it far enough to bring durable advances to an industry in which Germany is superior to us."[80]

HOW TO SAMPLE

GOOD EXAMPLES Most of the best bières de garde come from France: Duyck's Jenlain Ambrée, 3 Monts's Bière de Flandre, and Goulant's La Goudale are widely available in France and sometimes in the United States. Russian River's Perdition, which is brewed in California, is easier to find stateside.

TEMPERATURE Room to cool.

LOOK FOR A pour that can range from golden to light brown with a fluffy, sustained head and lace left on the glass. The flavor will have notes of honey, caramel, and hard candy at the start, and a dry, lingering finish will balance between sweet and bitter. The ABV is between 4 and 8 percent.

(SAISON)

WHY NOW?

Because saison is a style closely associated with the small kingdom of Belgium, which celebrates its independence from the Netherlands on July 21, in keeping with July's revolutionary theme.

BACKSTORY

Saison—the Belgian branch of the farmhouse ale family tree—emerged as a proper commercial effort by the late nineteenth century. Breweries producing the style by then were particularly prevalent in Hainaut, a province on the French border in the French-speaking southern half of Belgium known as Wallonia. Before these breweries, laypeople produced the style throughout Wallonia, though

not necessarily on farms—and some produced it outside Wallonia.[81] There are early and mid-nineteenth century references to "saison" in the industrial city of Liège, which is well outside of Hainaut, and in the Brussels area, which is outside of Wallonia altogether. Further complicating things was the tendency of Belgian brewers to attach the phrase "de saison" to a beer brand or style that wasn't a saison at all. (Why "saison" anyway? See "About the Name".) Still, by the late nineteenth century, those Hainaut breweries were using "saison" to describe what was becoming a distinct style produced in the cooler months for consumption in the warmer ones. It was also said to be a way to put any unused post-harvest grains to good use.

There is no clear originator or birthplace of saison, not even in its modern iteration like its cousin bière de garde.[82] Instead, it seems to be the offspring of the fertile imagination of the Belgian people when it came to beer. Before the rise of craft beer in America, Belgium reigned as the world's undisputed leading beer innovator.

One theory regarding saison's origination holds that Germany's beer purity regulations—most prominently Bavaria's sixteenth-century Reinheitsgebot—drove innovation northwestward. Another theory claims that the hop fields of what became Belgium in the 1830s made it a natural petri dish for beer. A third holds that the Maryland-sized kingdom of Belgium fell between wine-loving France

and beer-loving Germany, so it imbibed from both to make unique fare. However it happened, by the time saison emerged as a distinct style, Belgium hosted a vast and varied array of ales. Many of them, including saison, were deeply rooted in one region or place. For instance, there is no real style equivalent of saison in Belgium's Flemish-speaking northern half, known as Flanders, though Flemish breweries might produce saison. And saison, despite being created just miles away from the French border, developed in a distinctly different manner than bière de garde. It's dry, sourish, and herbal, whereas bière de garde leans into the lush, sweet, and grainy.

Interestingly—and perhaps in a bit of torch passing—by the twenty-first century, the United States was producing the most varied and intriguing iterations of saison, using a level of experimentation and exploration that nineteenth-century Belgian brewers would be familiar with. This more than anything else has kept the style robustly alive, and American saisons have come to be associated with summertime, as they are lower in alcohol and lighter in taste. This evolution also underscores a vivid, ongoing trend in this golden age of beer: American brewers borrow recipes and techniques for classic European styles and then run with them.

Ommegang's Hennepin out of upstate New York is a classic example of a saison beer.

ABOUT THE NAME

Saison means "season" in French and highlights the style's origins as a beer to be made in fall and winter for enjoying in the spring and summer.

TRIVIA

What's the earliest reference to saison in Belgium's Hainaut province? In 1858 the pub Le Petit Caporal, located in Charleroi, outside of Brussels, "promised two liters of 'bière

de saison' to anyone who would reach a 'nine four' in a bowling game," according to Dutch beer historian Roel Mulder. It's unclear if the pub was directly named after Napoleon Bonaparte, as his troops sometimes referred to him as *le petit caporal* (the little corporal), or for the species of hawk subsequently named after him.[83]

HOW TO SAMPLE

GOOD EXAMPLES Try Saison Dupont for a Belgian original. Then try American-made ones such as Allagash's Saison, Ommegang's Hennepin, Boulevard's Tank 7, and Goose Island's Sofie.

TEMPERATURE Room to cool.

LOOK FOR A pour that's honey yellow to pale orange with a grassy aroma, a lot of carbonation, and a rocky, sustained head like thick clouds from an airplane window. A slightly sour, lemony taste should end dry and without too much bitterness, and there should be an alcoholic kick of anywhere from 4 to 7 percent ABV (though the American ones tend to be stronger and more complex).

FOURTH WEEK OF JULY
THIS WEEK'S STYLE

KRIEK

WHY NOW?

Because this light cherry beer is perfect for that hot, humid time of year when stone fruits peak.

BACKSTORY

Kriek is a lambic made with cherries. What is a lambic? It's a type of fermented grain beer brewed in such a way that it's almost wholly distinct from ale or lager—in other words, an entirely separate, third offshoot of beer. Lambic emerged from the present-day Belgian region of Pajottenland, southwest of Brussels, in the thirteenth century.[84] It's possible that people were brewing lambics well before that, given the open-air spontaneity of its fermentation

Opposite: A worker at the seventeenth-century Liefmans Brewery in Belgium infuses the mash with cherries.

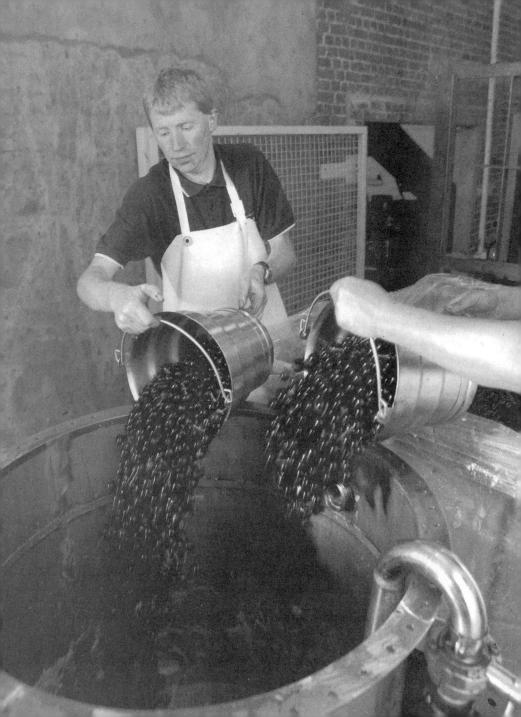

and its use of unmalted grains, but most research agrees that the thirteenth century is an origin point for this quirky and satisfying style undergirded largely by unmalted wheat and barley.

Spontaneous fermentation defines lambic. Fermentation vats are left open for yeast from the air to settle on the wort and change the sugars into ethanol. ("It takes just one night for consummation to take place," Michael Jackson once lasciviously wrote.)[85] Then there is a second fermentation that lambics undergo in the cask or keg, which rounds them out. It's the first spontaneous fermentation with wild yeast, though, that sets lambics apart from ales or lagers.

Of course, wild yeast powered all brewing before people understood the role of yeast in brewing. Before this, lambics were nothing unusual—they were simply beers made by certain Belgian breweries, and there might have been other examples across the beer-drinking world.

As isolated strains of brewing yeast became widely commercially available in the nineteenth century, spontaneous fermentation became something of a historical curiosity. By the late twentieth century, perhaps ten breweries in Pajottenland were making true lambics. And those breweries might have stopped brewing lambic were it not for Jackson, who became a champion of the style in the 1970s. His research and writing introduced lambic to an

Opposite: Kriek, such as this one from Liefmans, is a lambic beer infused with cherries and has a deliberately sour taste.

English-speaking audience, including in the United States. The best and most popular lambics remain Belgian-made, but American importers and some US brewers have been pivotal in their rebirth in recent decades.

As for the kriek sub-style of lambic, the use of fruit in brewing was likely already hundreds of years old when the first lambic brewer decided to add cherries to the secondary fermentation sometime between the thirteenth and nineteenth centuries. Kriek endured through lambic's ups and downs and has emerged as probably the most popular lambic style.

ABOUT THE NAME

Kriek means "cherry" in Flemish. The style is often called "kriek lambic" as well.

TRIVIA

The name "lambic" comes from the town of Lembeek, the Belgian area most associated with the style. The now-tiny town has neolithic roots and was an early example of humans gathering and staying in one place to live and toil rather than moving about nomadically to hunt and subsist. Given that Lembeek has been a brewing hub for centuries, it's possible that its earliest inhabitants settled down to cultivate grain to make some spectacular beer.[86]

HOW TO SAMPLE

GOOD EXAMPLES Most of these are going to be from Europe; try Lindemans's Kriek, Boon's Kriek Boon, Cantillon's Lou Pepe Kriek, and Timmermans's Kriek Lambicus. To try krieks made stateside, go for New Belgium's Transatlantique Kriek, which is made in Colorado, and Cascade's Kriek, which comes from Oregon.

TEMPERATURE Cool to cold.

LOOK FOR A ruby red pour with a lot of carbonation and a thick, sparkly head that should dissipate quickly. The taste should be tart but sweet and lush with notes of fruit and bubblegum. The finish should be dry with little to no bitterness. Some American interpretations come off as deliberately, puckeringly sour. European versions are more naturally tart. The ABV should be below 5 percent.

BORN IN THE USA
BEER STYLES NATIVE TO AMERICA

With credit to America's melting-pot nature, different cultures tossed together—willingly or not—form the churning mosaic that has powered the growth of the country since its beginning.

That same process has driven the growth and variegation of its beer and brewing.

Just look at how the styles that were born in the United States compare to those born abroad, especially in central and northern Europe, where most beer styles originated. Each style native to the United States is really an amalgamation of styles born elsewhere (much as most Americans are descended from people born elsewhere). Techniques from overseas—and variations on those techniques that Americans often hastily improvised—gestated these styles.

As such, with one exception, the styles felt more like unique accidents of history, rather than the offspring of other styles popular with the locals, and their survival was

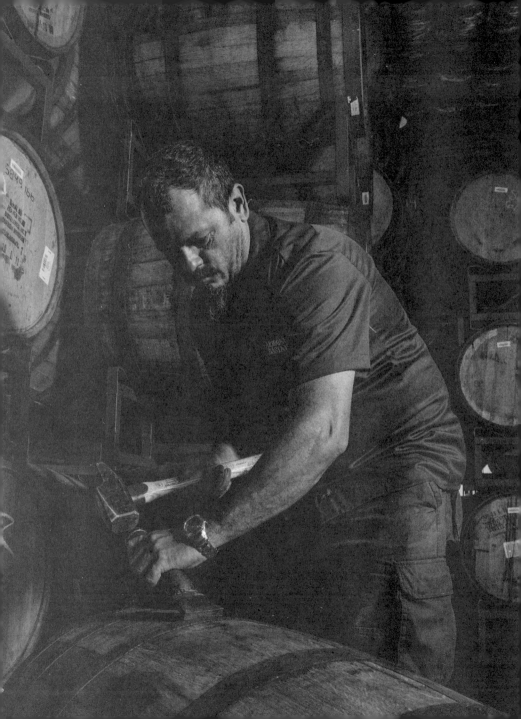

often due to either careful marketing or that simple human need to knock one back every now and then.

STEAM

Steam beer was born in California in the mid-1800s. A gold rush around Sacramento drew thirsty newcomers who experimented with whatever brewing ingredients and equipment they could get a hold of. The result was a lager-ale hybrid that came out of the keg with a puff of steam, poured with a distinct bubbliness and a clean, copper color, and produced a foamy head. Or at least that's how the story goes.

The modern iteration of steam beer dates from several decades after the gold rush when the style was in the firm legal grasp of one San Francisco brewery: Anchor. The Anchor Brewing Company has owned the trademark on "steam beer" ever since, and as a result was able to define its parameters into the twenty-first century. Today other brewers of the style sometimes refer to it as "common beer" to get around Anchor's trademark.

LIGHT

The post–World War II race to develop a lower-calorie beer that would appeal to the masses was finally won by

Previous: Ale brewed at the Stone Brewing Company gets aged in barrels previously used to age bourbon whiskey. This process leaves ales with a tangy, sour mash taste and can increase the alcohol content.

Milwaukee-based Miller Brewing Company in the early 1970s, and the company became one of the world's largest brewers as a result.

Miller's light beer, which it called Miller Lite, was invented by biochemist Joseph Owades, who had rejiggered beer's very chemistry to siphon out some of the highly caloric carbohydrates, leaving behind an exceedingly dry, thin version of the classic Czech–style pilsner. What really set Miller Lite apart, though, was its brewery's deftly brilliant advertising campaign, which leaned as much into highlighting the beer's "beery" taste as it did its lower calorie count. (Drinkers of a certain age will remember "Tastes great, less filling" and "Everything you always wanted in a beer. And less.") Soon, mass-market light beer imitators were popping up on both sides of the Atlantic, chasing the market for what became the most popular beer style.

KENTUCKY COMMON

For centuries beer was an intensely local affair—oftentimes so local that it largely existed as the product of individuals who brewed for their own household or small circle of friends, family, and acquaintances. (In the case of medieval monasteries, these acquaintances included travelers seeking sustenance.) These lone brewers put their own spins on existing styles, and sometimes word of a particularly interesting brew took off and demand for it grew. This was

the case with Kentucky common, which was probably originally made in someone's home or tavern in the area around Louisville, Kentucky, in the early to middle nineteenth century. Kentucky common married lager and ale in a beer that could be made relatively quickly—from mash to mug in about two weeks—and that poured dark and effervescent. Like steam and cream ale, Kentucky common was born of the necessity of pioneers pushing westward who wanted to have a beer like they'd had back east or in the old country.

As brewing became a commercial enterprise with customer bases, supply chains, and scales of production, Kentucky common all but disappeared. Dogged researchers and brewers in the twenty-first century reached back and rescued it.

CREAM ALE

This knockoff of the classic German style kölsch was born in the nineteenth century and came of age in the Upper Midwest or the Northeast. The accidental inventor or inventors of cream ale leaned into using corn and rice in brewing to thin out the often-globular six-row barley widely available in the United States. (Back home, German brewers could find two-row barley in abundance, and it led to cleaner, crisper beers.) What came of this take on kölsch with corn

and rice was a bubbly, creamy ale of exceptional lightness. That lightness ensured this ale a place in a beer world that lager was increasingly coming to dominate. A marketing executive from the late twentieth century might have hailed cream ale's "drinkability."

Genesee Cream Ale from the Genesee Brewery in Rochester, New York, was the best-selling ale in the United States by the 1960s. All other major commercial beers were lagers in the pilsner style (and outsold Genesee Cream Ale manifold). After Genesee and a handful of other cream ale producers carried the style's torch into the end of the twentieth century, craft brewers picked it up and ran with it, multiplying the options on offer and helping the ale to find a wider audience.

MEXICAN LAGER

It would be tempting to say that Mexican lager has dual citizenship. Its roots, or "grandparentage," definitely stretch to the mid-1800s in Mexico. But it was likely born in the United States in the early 2000s. How'd this happen? There had been brewing for centuries in what became Mexico by the time the French Emperor Napoleon III installed a puppet regime led by the Austrian Archduke Maximilian in Mexico City in April 1864. This short-lived rule—rebels would capture Maximilian and execute him in June 1867—

was apparently enough to draw a relatively large number of Germans and Austrians to Mexico. They brought with them a taste for European beer and techniques for brewing it. For a time afterward, brewers in Mexico mimicked great European styles such as Vienna lager and pilsner.

North of the Rio Grande, brewing became more about scale than about style, so brewers and their descendants steered Mexican brewing toward their own take on great European styles. They wanted beer that was cheap to make and easy to sell. Lager for and from Mexico became formulaic, and the carefully mass-produced formula was light-tasting, light on bitterness, and light in color, if not also light in alcohol content. Corona and Tecate are prime examples. If not for American craft brewers, some of Mexican descent, who saw the potential for a premium upgrade, Mexican lager would not have developed into the more refined style we know today.

NEW ENGLAND INDIA PALE ALE

There were hazy, juicy, exceptionally bitter India pale ales and pale ales prior to the 2000s, when a coterie of American craft brewers seized on the approach to create a new style. Indeed, IPA dates back to at least the late nineteenth century, to a time when filtration in brewing was not that exact a science and many a finished product came

out cloudy. So hazy, super-bitter IPAs were not unheard of, but they were more of an aberration rather than a style.

Enter Heady Topper from Vermont's Alchemist brewpub in 2004. This was an IPA made with methods known to result in an uncommon murkiness, and it touched off what seemed at the time to be a regional fad. These new beers were *really* bitter and *really* cloudy and *really* high in alcohol—and, according to a lot of critical takes, really difficult to drink in volume. The fad became a proper style, though, thanks to a confluence of factors and a hearty dose of good timing. The wider craft brewing industry had just undergone a big shakeup at the turn of the millennium. A lot of breweries closed, brands ceased production, and, momentarily, the entire craft beer movement itself seemed like a fad. It was time for new players and new ideas, and there was New England IPA in all of its cloudy glory. Within ten years of the Alchemist's alchemy, New England IPA was a bona fide style. The surest proof was the fight over what constituted a proper New England IPA, and adjectives like hazy, juicy, and strong became the winning definers.

INDIA PALE LAGER

India pale lager came into being in the late 2000s. The first IPL might have been introduced by the now-defunct Shmaltz Brewing Company out of New York City, which launched a

Sword Swallower American Pale Lager in 2007 that had all the hallmarks of what came to be called India pale lager.

IPL was a reaction to IPA. India pale ales by the start of the twentieth century had evolved into big, hearty brews of particular pungency and strength. This was especially true in the United States, where West Coast takes on the style were notably bitter, and East Coast versions were distinctly cloudy (which became a hallmark of what turned into the New England IPA style). What about a happy median between ridiculously bitter and stonkingly strong? That was the IPL. The lager yeast rendered these beers cleaner and drier, not as floral or fruity as their IPA cousins. They might still pack a hoppy pungency, but a malty finish usually tamed it. Here was a smooth style that nodded to the American craving for brash and bold but didn't lose itself in service to it.

FIRST WEEK OF AUGUST
THIS WEEK'S STYLE

(INDIA PALE ALE)

WHY NOW?

Because IPA Day, the most celebrated made-up day in the American beer calendar, is the first Thursday in August.

BACKSTORY

The origins of craft beer's most popular style—essentially a hoppier version of pale ale, distinct for its bitterness and strength—are shrouded in legend. The most pernicious of these legends is that the style was invented for British troops in India in the late 1700s. The legend goes something like this: Brewers in London added generous amounts of hops to existing pale ales because hops not only spice beer, but also preserve it. Otherwise, the pale ales

India pale ales, like this one from the Harpoon Brewery in Boston, enjoyed a resurgence in the early 1990s.

shipping to troops in India would never have survived the long voyage.

Pretty much none of that is true. The "troops" in what became Pakistan, India, and Bangladesh were not British military, but mostly private mercenaries of the ruthless East India Company. Any pale ale being shipped didn't need much additional preservation for the trip anyway. The most popular beer style on the colonial subcontinent, after all, was the less hoppier, darkly sweetish porter, and that made the voyage from London just fine.

Another enduring IPA myth is that a particular brewer near the London docks named George Hodgson invented the style. There was a George Hodgson brewing in the late 1700s and early 1800s, and he did brew hoppy pale ales for export, but he wasn't the father of India pale ale. In fact, the style and the name don't appear to have come into any sort of vogue until the mid-1800s—decades after the legends say IPA was born. By then, hoppier pale ales were indeed making their way to an increasingly competitive Indian beer market; however, IPA still played second (or third or fourth) fiddle to porter, mild, and pilsner, and pale lager in general, in any place that the British controlled.

As late as the 1980s, IPA barely received a mention in even the more sophisticated beer guides. When it did, those mentions came replete with the phony origin stories, especially the bit about being aimed at the Indian market. Improbable as it seems now, given its ubiquity, IPA would have to await the end of its third century before it scaled any serious commercial summits. This was because in the 1990s American craft brewers rekindled an interest in IPA and leaned heavily into its hoppy character (the British originals were likely far less bitter).

The first IPAs made in America predate the nineties, of course—P. Ballantine & Sons was making IPA as early as at least the 1870s, and it became a standard that craft brewers like Sierra Nevada looked toward. But the rocket ship rise

began in the nineties. The reasons are unclear, but likely had something to do with craft brewers' general revulsion at the monochromatic nature of American beer at that point. They wanted something heavier, sharper, and stronger than the watery versions of pilsner flooding the market. IPA it was.

ABOUT THE NAME

Somewhere along the way, probably in the early 1800s, British brewers' hoppier pale ales became linked with the export market to India. When they did, they were at first called "East India Pale Ale," after the private company that was then exploiting the subcontinent, a designation that still endures on some labels.

TRIVIA

The earliest known reference in print to "India pale ale" or "East India pale ale" comes from neither the United Kingdom nor India, but from an ad in the Australian newspaper the *Sydney Gazette and New South Wales Advertiser* on August 29, 1829.[87] In the United States, the earliest reference appears to be in an ad for "London East India Pale Ale, in Jugs," in Virginia's *Daily Richmond Whig* on June 12, 1841.

HOW TO SAMPLE

GOOD EXAMPLES Take your pick from the wealth available—just about every one of the thousands of breweries in the United States offers an IPA. Or go with a classic like Sierra Nevada's Pale Ale, which is probably the template for every American-made IPA. Its Chico, California-based brewery is said to have used yeast cultivated from P. Ballantine & Sons's Ballantine Ale (another IPA in all but name). For an excellent example of the hoppier "West Coast style," try Lagunitas's IPA. Also out of Northern California, Lagunitas was the first brewery in California to lead with an IPA.

TEMPERATURE Cool to cold.

LOOK FOR A pale gold to amber brown pour with a fluffy, sparkly head that slowly dissipates, leaving lace on the glass. Dry, earthy, and crisp, with a distinctively tangy bitterness on the finish, a well-crafted IPA is bracingly refreshing, with a full, citrusy taste and an ABV of anywhere between 4 and 9 percent.

SECOND WEEK OF AUGUST
THIS WEEK'S STYLE

(LIGHT BEER)

WHY NOW?

Because we're in the dog days of summer and the eminently quaffable light beer is, well, the lightest beer around. It's also prime beach season and that can mean trying to stay slim(mer).

BACKSTORY

Modern light beer was first available in August 1973, when the Miller Brewing Company test-marketed what it would sell as Miller Lite in four US cities. It would roll out nationally just after New Year's Day in 1975 and quickly ignite a light beer war that saw the style become the most popular in the United States and then the world. (There had been

Opposite: Miller Lite's debut in 1973 changed the brewing landscape forever, introducing thinner, lower-calorie, lower-alcohol beers to the masses.

earlier iterations of "light beer," including an early version of Coors Light that lasted about a year in the early 1940s, but these earlier iterations either fizzled out commercially, or, as in the case of the early Coors Light, did not have fewer calories than other beers and were instead marketed as light because of their color or taste. The modern—low-calorie—Coors Light appeared in 1978.)

What made Miller Lite light calorically? It was hard to definitively say, as Miller and its later competitors—beginning with Schlitz, which would begin brewing Schlitz Light the following year, and Anheuser-Busch, which would begin brewing Natural Light in 1977 and Michelob Light in 1978, the same year as the new Coors Light appeared—played their recipes close to the vest. What is known about the recipe for the formative Miller Lite is that it came from a biochemist named Joseph Owades. While working at the Brooklyn-based Rheingold Brewing, Owades developed a way to isolate an enzyme that breaks down higher-calorie sugars during fermentation and makes them easier to convert to alcohol. There had been attempts at lower-calorie, lighter-tasting beers since the 1940s, but until Owades's brew none had been flavorful enough to lead to a commercial success. Brewers had simply watered down existing pilsners in clumsy attempts to flush out calories and have their beers pass as light.

An early version of light that Owades developed for Rheingold—called, directly enough, Gablinger's Diet Beer—failed, likely due to both the novelty of the product and the way it was marketed. Its campaign included commercials that showed an overweight man stuffing himself with spaghetti but also drinking a Gablinger's Diet Beer, as if conscious of his weight.

Owades—whether with Rheingold's permission or on his own—had shared his formula with a friend at Chicago-based brewery Meister Bräu. That brewery came out with its Meister Bräu Lite in May 1967 (the first time "light" appeared as "lite" on a beer) and, for a time, it appeared to have commercial legs. Meister Bräu was careful to talk up the beer's fewer calories, but also its tastiness. "Meister Bräu gives you more of what you drink beer for," went an early ad.[88] But Rheingold pushed back in court and scored a patent on its low-calorie approach in 1968. Meister Bräu soon faltered financially as a result, and in 1972 it fell into the arms of Miller Brewing. Miller Lite came out the next year.

Miller Lite, working with its ad wizards at the agency McCann Erickson, eschewed the earlier, failed beers' attempts to tie light beer to losing weight. Instead, Miller's ads would go all in on their light beer's beeriness, using such slogans as "Great taste, less filling" and "Everything you always wanted in a beer. And less." Usually delivered by ex-pro athletes, these became household catchphrases, and light beer was off to the consumer races. "Light" everything, in fact, became voguish following Miller Lite's 1975 national rollout. The idea of "light" this or that—from foodstuffs to albums to ideas—"took on a life of its own" after Miller Lite, according to the *New York Times*.[89]

ABOUT THE NAME

Neither Meister Bräu nor Miller came up with "lite." The bastardization of "light" dates from at least the nineteenth century and meant exactly what it was supposed to mean: a less substantial version of something.

TRIVIA

The idea for Miller Lite was born at a business dinner in Munich in 1972 between George Weissman, chairman of tobacco giant Philip Morris, and John Murphy, CEO of Miller—which Philip Morris had just acquired. Weissman was on a diet and asked the waiter what kind of beer he should have. The waiter suggested a *diät* pilsner, an exceptionally dry beer aimed at diabetics. Despite the name ("*diät*" means "diet" in German), the style was not necessarily lower in calories, just sugar. But Weissman liked it, and he liked the concept as he understood it, and the rest was history. His brewery would soon set about creating its own low-calorie beer.[90]

HOW TO SAMPLE

GOOD EXAMPLES Miller Lite, Bud Light, Sam Adams Light, Night Shift's Nite Lite. There are also a number of low-calorie IPAs on the market, including Dogfish Head's Slightly Mighty and Lagunitas's DayTime.

TEMPERATURE Cold.

LOOK FOR Most light beers are based off pilsners stylistically. Look for a pale golden pour with a lot of carbonation. Depending on the brand, the head will drop quickly or retain its foaminess. The mouthfeel should be crisp and crackly, with a very dry finish and little bitterness (unless it's a light IPA). The kick is—you guessed it—on the lighter side, with generally no more than 5.5 percent ABV.

INDIA PALE LAGER

WHY NOW?

Because this inspired style is a perfect companion for a big summer barbecue—think juicy burgers and late summer produce like tomatoes, corn on the cob, and green and yellow squash.

BACKSTORY

One of the youngest beer styles, India pale lager as a distinct style—a sharply hoppy lager with a honeyed hue and a clean, lean mouthfeel—was born in the United States in the 2000s. The earliest media references to India pale lager, or IPL, came a few years later. The *Washington Post* referenced "India pale lagers" in a 2013 article, highlighting an IPL from the old

Shmaltz Brewing Company of New York that had debuted in 2007 as an example.[91] A 2015 article from the *New York Times* about a tasting panel of lagers described a "so-called" India pale lager.[92]

Neither the Great American Beer Festival nor the Beer Judge Certification Program—the latter a program that often mints judges for the former—had a separate IPL category at the start of the 2020s, but GABF would add one in 2022 and both had categories for specialty lagers.

What exactly is India pale lager? A lot of what characterizes it is in the name and in the rise of what we might call its older cousin, India pale ale. Like that much older style, a hoppy bitterness defines IPL. Given that it's a lager, however, IPL is generally not as dense or heavy as IPA. And while the trends in IPA over the past twenty years have been pushing it to extremes—as seen with the rise of super-hazy, super-juicy New England IPAs and the enduring popularity of the super-bitter double IPA—the trends in IPL have been toward a cleaner, leaner taste and feel.

ABOUT THE NAME

India pale lager has nothing to do with India. The name is a play on India pale ale, given their shared bitterness. Both that popular ale style, which developed in nineteenth-century England and enjoyed its renaissance in late twentieth-

century America, and IPL lean on hop varietals such as Cascade, Simcoe, and Citra that are well-known for providing bitterness and floral aroma.

TRIVIA

What gives IPL its cleaner, leaner taste? Almost certainly the lager yeast. It produces fewer organic compounds, called esters, than ale yeast, where they can be found in abundance. Esters can cause savory fruit flavors that are hallmarks of some ales but that should not predominate in a lager.

HOW TO SAMPLE

GOOD EXAMPLES IPL is still almost entirely a US phenomenon, so the ones you'll find are made stateside. Try Jack's Abby's Hoponius Union, von Trapp's Double IPL, and Hill Farmstead's Song of Joy.

TEMPERATURE Cool to cold.

LOOK FOR It should pour busily, with plenty of foam, bubbles, and maybe even yeast detritus, and will have a straw to dried honey color and a stable head. Embrace the balance between malty sweetness and hoppy bitterness with a dry, crisp finish and little of the acerbity that its cousin IPA carries. IPLs are not as in your face—in fact, the brewers behind the young style seem to relish evolving away from the hoppiness that defines so much American craft beer, though they can be similarly strong at between 5 and 8 percent ABV.

FOURTH WEEK OF AUGUST
THIS WEEK'S STYLE

WEISSBIER

WHY NOW?

Because it's hot out and weissbier is especially tangy and refreshing. Plus, this wheat-forward beer is the perfect celebration of the end of the wheat harvest in North America.

BACKSTORY

Weissbier is most closely associated with Bavaria (a lot of things in beer are most closely associated with Bavaria), but was likely born in neighboring Bohemia (land that later became Czechia) in the twelfth or thirteenth centuries. By that time, brewers and homebrewers had for millennia been using wheat in beer, and weissbier is made with wheat comprising most of its grain bill

rather than barley. In the hands of the Bavarians rather than the Bohemians, weissbier came into its own. In fact, it became so popular that when the Wittelsbachs, Bavaria's ruling family, prohibited wheat in brewing through the famous Reinheitsgebot purity law of 1516, they carved out an exemption for a baronial clan called the Degenbergs who made some particularly tasty weissbier.[93]

The Degenbergs retained this carve-out until 1602, when the head of the family died without a male heir. When that happened, the Wittelsbachs quickly claimed the exclusive franchise for themselves and held onto it well into the nineteenth century. By then, however, weissbier's popularity was on the wane, and it would drop off a cliff as pilsner and other lighter lager styles flooded the Bavarian market. The royal family was happy—and lucky—then, to part with the brewing rights in 1872 and sell them to brewer Georg Schneider. He and his descendants would brew weissbier at Schneider Weisse Brewery, first located in downtown Munich and later in Kelheim, Bavaria.[94]

Wheat beer in general, not just the weissbier style, enjoyed a consumer renaissance in the late twentieth century when American craft brewers became interested in it. Early craft brewers—especially Widmer Brothers, founded in 1984 in Portland, Oregon—produced wheat beers that quickly became popular and led to the style's endurance into the twenty-first century.

ABOUT THE NAME

Weissbier is German for "white beer." Simple enough. But weissbier also goes by *weizenbier*, German for "wheat beer," and popular variations within the style abound. The cloudier, unfiltered version is *hefeweizen* (*hefe* means "yeast"), and there's the darker *dunkelweizen* (meaning "dark wheat"). Hefeweizen in particular is popular in the US. Finally, there's the separate witbier style, which is a Belgian take on wheat beer.

TRIVIA

Weissbier, especially hefeweizen, is the specialty of what's regarded as the world's oldest brewery: Weihenstephan in Freising, just outside Munich. Benedictine monks began brewing there in 1040, though the buildings you can still visit today date from about six hundred years later.

HOW TO SAMPLE

GOOD EXAMPLES Widmer Brothers's Hefe, Weihenstephaner Hefe Weissbier, Live Oak's HefeWeizen, Ayinger's Bräuweisse, and New Glarus's Dancing Man. These and others from both sides of the Atlantic are readily available in the United States.

TEMPERATURE Cool to cold.

LOOK FOR A yellowy straw color that's cloudy if it's a proper hefeweizen, with a fluffy, foamy head that sustains through the first several sips. There should be hints of banana and clove on the tongue and a sweet tanginess on the finish, with little hop bitterness. It's an exceptionally clean style with an ABV of approximately 4 to 6 percent.

BEER IN FALL

"These traditions of strongest beers for uncertain or cool weather have merged and mixed over the centuries."[95]
—MICHAEL JACKSON

If there is one time of the year when the appropriate styles of beer pivot sharply in taste, texture, and aroma, it's when summer fades to fall. The light, crisp, bright lagers cede to ales (and some lagers) of intense spiciness and opacity. Part of this shift is the simple desire in the Northern Hemisphere to embrace brews that are warming and worthy of longer contemplation amid longer, cooler nights and shorter, grayer days. Part of it is the seasonality of beer and its ties to agricultural, and sometimes religious, calendars: some styles were simply born of the fall harvest.

Opposite: A Sierra Nevada Brewing Company hops field. For centuries, hops have been the primary bittering and aroma agents in beer.

FIRST WEEK OF SEPTEMBER
THIS WEEK'S STYLE

$$\boxed{\text{WITBIER}}$$

WHY NOW?

Because wheat is harvested in September and October. Wheat-based beers are also particularly refreshing in the heat, and it's still hot in much of the United States in September.

BACKSTORY

The modern story of witbier, the Belgian style of wheat beer, reads like a charming fairytale or Hollywood underdog trope. Think *Rocky* if Rocky had been brewing beer instead of jumping in a boxing ring. As with the similarly wheat-heavy weissbier style from Bavaria, the roots of witbier likely lie in northern and central Europe in the early Middle Ages. The modern roots, however, stem from a mid-twentieth century

milkman who carried a torch for the sights and smells of his tiny Belgian hometown. This milkman, Pierre Celis, grew up in the working-class village of Hoegaarden, about thirty miles southeast of Brussels. Hoegaarden had been the nexus for a style of wheat beer flavored with spices, such as coriander, and fruit, such as orange peel. At one point the village had been home to dozens of breweries, but shifts in the industry had driven them all out of business by the late 1950s, devastating the local industry.

Celis had worked part-time at one of these breweries in his youth, which inspired him to dabble in homebrewing as an adult. He made a witbier from the ingredients he remembered from his time at the Tomsin brewery, and the creation proved such a local hit that Celis began brewing professionally in 1966. He installed secondhand equipment in the stables next to his house, and the operation—initially named after himself, Celis, and then after its hometown, Hoegaarden—quickly expanded, first beyond his community and then throughout his country and the world.

A fire devastated the under-insured Celis just as he was about to start exporting his witbier to the United States in the mid-1980s, and brewing giant Stella Artois stepped in with a rescuing stake. Even so, Celis would eventually lose control of the brewery after further business deals. But by then the witbier style Celis had saved had become a global phenomenon, including in the United States.[96]

Celis later moved to Austin, Texas, to open another witbier brewery under his own name. Celis Brewery proved another hit, but it too would be sold, eventually ending up under Miller's corporate wing. Celis the man cashed out in 2000, and returned to Hoegaarden a local hero.

ABOUT THE NAME

Witbier means "white beer" in Dutch and its Belgian derivative, Flemish. In French-speaking areas, including the cafés of Paris, the style will show up as *bière blanche*.

TRIVIA

Never come between Belgians and their local beer. When Celis returned to Hoegaarden in the early 2000s, he found that his original brewery's latest corporate parent, Piedboeuf, intended to move production from Hoegaarden, in the Flemish-speaking north of Belgium, to a plant in its French-speaking south. That set off mass protests in Hoegaarden under the banner "Hoegaarden Brews Hoegaarden." Move the operation, though, Piedboeuf did—only to see sales plunge. Production soon returned to Hoegaarden.[97]

HOW TO SAMPLE

GOOD EXAMPLES Both craft and macrobrewers embraced witbier with a vengeance, and the end results are a mixed bag. Try Allagash White, Bell's Oberon Ale, Harpoon's UFO White, and Ommegang's Witte for more artisanal takes. Try Hoegaarden's witbier for a sweeter and less nuanced manifestation of the original, and try Blue Moon's Belgian White from the best-selling US brand for a macro version.

TEMPERATURE Cool to cold.

LOOK FOR A golden, cloudy pour with a fluffy, lasting head (the cloudiness should clear as it rushes toward the head), a zesty fruitiness with lemon-orange upfront and dry pepperiness on the finish, and an ABV of no more than 6 percent. Tartly refreshing, witbier is one of those styles you wish you were already well familiar with, especially come summertime.

SECOND WEEK OF SEPTEMBER
THIS WEEK'S STYLE

(STEAM)

WHY NOW?

Because the nights are getting cooler, even as the days stay warm, and steam beer is the perfect brew to bridge that divide. Plus, California became the thirty-first state on September 9, 1850, and steam beer is intimately tied to the Golden State.

BACKSTORY

The only beer in all of America, and much of the world, that's legally allowed to be commercially marketed as "steam beer" is made in California, where the style is from. The story behind why dates back to the gold rush, when the 1848 discovery of the precious metal in the hills near Sacramento led to a massive influx of people from all over

the globe. These arrivals wanted all the comforts of home, including beer.

But what to do when the ingredients and equipment for beer were in scarce supply? They say necessity is the mother of invention, and it appears that that's how steam beer came about. Early brewers of the accidental style used what they had, throwing lager yeast into thicker ale recipes and leaving the boil outside, where the lager yeast, normally most comfortable at cooler temperatures, converted the sugars during a fermentation at higher temperatures. There was no artificial refrigeration at the time, and no one wanted to take up space in cooler caves that might be holding gold.

Okay, that last part of the origin story—saving the caves for gold hunting—may not be true, but the part about a lager-ale hybrid certainly *is* true. Steam beer developed in California post–gold rush and was a commercially available style by the end of the century. The brewery that would carry it into and through the twentieth century, Anchor Brewing, started brewing in 1896 in San Francisco.

Anchor Brewing was likely one of several breweries in California that produced steam beer around the turn of the century; however, they wanted exclusivity, and in 1934, just after the repeal of Prohibition, requested a trademark for it. With the trademark request, Anchor claimed itself as the only brewery that could make the style and call its beer "steam beer." But the claim wasn't enough to frighten off

imitators, even though the brewery was never shy about threatening legal action.

The official trademark registration wouldn't be approved until September 1978, and by then the American craft beer movement was well underway. Anchor, more than any other brewery, had helped to create the craft beer movement under owner Fritz Maytag, a benevolent appliance heir who bought control of the then-struggling brewery for "about the price of a used car" in 1965.[98] The official trademark did dissuade other breweries from calling their offerings "steam beer," so Anchor got to legally and stylistically define what steam beer should be. Earlier versions are lost largely to conjecture, though Anchor claimed its own recipe has changed little since 1896, even if Maytag has said that the quality had worsened by the 1960s. "When it was good, which was not too often, it tasted very much like what we have today," Maytag told a reporter in 1996. Maytag would cease the use of corn syrup in the Anchor Steam recipe—likely added as a cheap way to speed fermentation—and hew more toward the 1890s original. In doing so, he touched off the American craft beer revolution.

ABOUT THE NAME

There are various legends regarding the name's origins; among them that a guy named Pete Steam invented it and that "steam" somehow became slang for "beer"

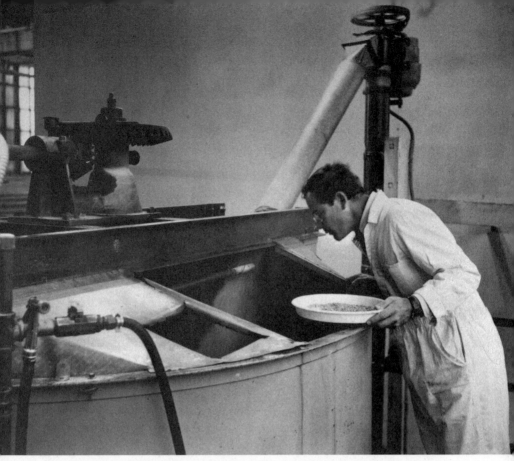

Fritz Maytag, who rescued Anchor Brewing in the late 1960s, examines one of its tuns.

in gold-mad California, where early breweries used steam power. The likeliest explanation is the simplest: that it describes how the open cooling of the hot mash in the generally mild and breezy Northern California climate would produce steam. To get around Anchor's trademark, several breweries offer what's called "California common," beer of the steam style in all but name.

TRIVIA

Fritz Maytag got the idea for buying the Anchor Brewing Company from Fred Kuh, the owner of a quirky hangout, The Old Spaghetti Factory Café and Excelsior Coffee House, in San Francisco's North Beach neighborhood. Kuh knew who Maytag was and knew that he liked the Anchor Steam on draft at the Old Spaghetti Factory. Kuh also knew that the current owners of Anchor—the nation's last independently-owned brewery to make beer with traditional ingredients and methods—were hanging on by a thread in a rapidly consolidating brewing industry.

"Fritz, have you ever been to the brewery?" Kuh asked his patron one day in August 1965 as he set a glass of Anchor Steam in front of him. "It's closing in a day or two. You ought to see it. You'd like it."[99]

Maytag had not been. He would go the next day—a mile and a half walk from his apartment—and buy a 51 percent stake. It was the start of the American craft beer movement.

HOW TO SAMPLE

GOOD EXAMPLES Anchor's owner, Sapporo, the Japanese brewing giant, shuttered Anchor abruptly in July 2023 due to sluggish sales and other cutbacks. (Chobani yogurt magnate Hamdi Ulukaya bought Anchor in 2024, but as of November of that year had not reopened it nor restarted production.) The odd bottle or can of Anchor Steam can still be found, but the best examples of the style are now found in what are called California commons. Unfortunately, these commons tend to be seasonals or special one-offs for breweries with only regional footprints. The collapse of Anchor resulted in the end of nationwide distribution of the style. In Massachusetts, Tree House Brewing's Promised Land is an excellent example of the steam/common style.

TEMPERATURE Cool to cold.

LOOK FOR A cross between an ale and a lager in any California common. So you're getting a light, effervescent beer with a clean look and finish that is thick and fruity with a little bitterness. The strength shouldn't stray beyond 6 percent ABV.

THIRD WEEK OF SEPTEMBER
THIS WEEK'S STYLE

(BRAGGOT)

WHY NOW?

Because honey, the base of this ancient style, plays a central role in the Jewish holiday of Rosh Hashanah, symbolizing hopes for a sweet new year. Curiously, the honey harvest in North America also usually wraps up around mid to late September.

BACKSTORY

If there's one beer style that someone from the Middle Ages transplanted to today would recognize—other than dark ale in general—it would be braggot. In fact, the style was centuries old by the time the Middle Ages rolled around and braggot enjoyed its first big heyday.

Braggot is essentially a combination of mead and beer, or more specifically, mead and the malt that goes into making beer. Mead is fermented honey—probably the oldest alcoholic beverage known to humankind, older than beer and wine— and made in much the same way that wine is made from grapes or other fruits. A mead maker would mix honey and water, add yeast, and wait out the fermentation process, after which the mead could be filtered and bottled. (The earliest mead makers would not have known about the role of yeast, just as the earliest brewers did not. Rather, they likely simply left out their honey and water for the wild spores of yeast in the air to settle on the mixture and do their chemistry. To them, it probably seemed magical.) The proportion of beer to mead in braggot is up to the individual brewer, but generally it's about half of each.

Braggot was a known style by the twelfth century. It came from northern Europe or the British Isles and then spread wherever fermented grain spread, which is to say everywhere. To drink braggot is to drink the great vicissitudes of culinary history. Later, esoteric European brewers kept braggot alive as a curiosity long enough for American craft beer fans to seize on it in the twenty-first century, just as it closed in on its one thousandth birthday, give or take.

ABOUT THE NAME

The reigning theory is that "braggot" comes from some forgotten combination of Gaelic meant to describe honey meeting malt. In modern Welsh, *brag* means "malt."

TRIVIA

How do we know that braggot was popular in the Middle Ages? Geoffrey Chaucer mentions it in "The Miller's Tale," part of his fourteenth-century *Canterbury Tales*, when he describes a young woman having a mouth as "sweet as bracket [sic] or the meth."[100]

HOW TO SAMPLE

GOOD EXAMPLES Given how esoteric braggot is, it's remarkable how many examples there are just in the United States. Seek out Samuel Adams's Honey Queen, Atlantic's Brother Adam's Bragget Honey Ale, Kuhnhenn's Braggot, and Flying Fish's Exit 3 Blueberry Braggot.

TEMPERATURE Room to cool.

LOOK FOR A deep amber to ruby red color; a thick, lasting head; an aroma of candi sugar (a caramelized sugar syrup); honey with buttery sweetness on the first sip and very little bitterness on the finish; and a refreshing quality stemming from a candy-like tartness that lingers in the mouth. Braggots have a wide range of ABVs, similar to barley wine, and some clock in at 10 percent or more.

MÄRZENBIER

WHY NOW?

Because märzenbier is the traditional beer of the sixteen-day Oktoberfest, which runs from late September into early October.

BACKSTORY

There is a lowercase märzenbier story and an uppercase Märzenbier story. The lowercase story starts in the 1530s, after Duke Albrecht V of Bavaria banned brewing from St. George's Day on April 23 to St. Michael's Day on September 29. This was because the cooler weather between September 29 and April 23 ensured a better quality of beer than brewing in the warmer months. The Bavarians didn't necessarily know why—brewing at the time was still more art than

science—they just knew there weren't as many infected, sour batches in the cooler months. As a result, Bavarian brewers would do their utmost to get their beers into aging barrels by the start of April, and would tap those beers in early September. The nickname for these mostly March-made beers, *märzenbier*, stuck.

This Bavarian märzenbier—still with a lower-case "m"—really came into its own after the original Oktoberfest in the fall of 1810 that was held to celebrate the marriage of the Bavarian crown prince. Because of the wedding date, it was one of the most readily available beers for the celebration. The timing stuck and the tradition of enjoying märzenbier at an annual Oktoberfest celebration continues in Munich to this day.

Märzenbier with a capital "M" dates to 1841, when Munich's Spaten brewery (today formally known as Spaten-Franziskaner-Bräu) released what came to be seen as the definitive example of the style. Spaten did not necessarily intend for it to be definitive. Its märzenbier that year was simply the usual September release ahead of Oktoberfest. But Gabriel Sedlmayr II, Spaten's principal owner, had traveled to England to research the latest malting and brewing techniques, and he was so enamored with light-colored ales that he brought this know-how to bear on the märzenbier he released that year. It led to an unusually light-colored märzenbier with a

malt-forward taste unencumbered by excessive bitter-ness, and other Bavarian breweries would glom onto it. (Sedlmayr's reputation probably didn't hurt—he and his brewery were held in high regard for their research and development.)

Märzenbier—now capitalized—became a distinct style intimately intertwined with Bavarian culture because of its prominence in *the* Oktoberfest, as well as Oktoberfest knockoffs globally. It was very likely German immigrants in the 1840s who staged the first Oktoberfests in the United States, complete with American-made märzenbier.

ABOUT THE NAME

Märzenbier is synonymous, especially in the United States, with Oktoberfest. So a lot of märzenbiers stateside are called Oktoberfests or Octoberfests. Some are also called *festbier*, which is exactly what it sounds like: festival beer.

TRIVIA

The father of the influential Duke Albrecht V of Bavaria was Wilhelm IV, the duke who in 1516 issued the Reinheitsgebot purity law that decreed that beer be made only from water, barley, and hops, which is widely considered the first food purity law.

Opposite: The märzenbier style is the basis for what most Americans know as Oktober-fest or Octoberfest beer, including the one from Samuel Adams.

HOW TO SAMPLE

GOOD EXAMPLES Try moving westward from European selections to domestic ones: Spaten's Oktoberfest, Paulaner's Oktoberfest Bier, Ayinger's Oktober Fest-Märzen, Samuel Adams's Octoberfest, Brooklyn Brewery's Oktoberfest, and Victory's Festbier.

TEMPERATURE Cool to cold.

LOOK FOR An aromatic malt bomb in the pour with a thick, sustained head and plenty of lacing left behind on the glass; a chewy, sweet mouthfeel and taste with only a dash of bitterness on the finish; a pour that is thin and clean, but not watery. Every proper märzenbier should be a lager in keeping with the style's origins, making it enjoyable to have one after another. The ABV is between 4 and 6 percent.

OUT OF THE BOX

You've had beer on tap, beer from a bottle, and beer from a can. What about beer out of the box? In 1985 the tiny two-person Golden Pacific Brewing Company out of Emeryville, California, became the first US brewery in the modern age—and maybe the first one ever— to box its beer for sale. It was not easy, given the pressure the carbonated beverage could throw off, but Golden Pacific soldered waxed cardboard boxes together around bladder-like plastic bags that held what they called Bittersweet Ale, a brew inspired by India pale ale. The company sold thirty to forty boxes a week locally at twenty-five dollars each.

Though the idea did not seem that far-fetched—boxed wine had been circulating in the United States since the 1970s—Golden Pacific eventually settled on bottles before founders Tad Stratford and Maureen Lojo sold the operation to their Emeryville landlords in 1990.[101]

FIRST WEEK OF OCTOBER
THIS WEEK'S STYLE

DUNKEL

WHY NOW?

Because October 3 is German Unity Day, a major holiday in one of the world's major beer nations that marks the reunification of East and West Germany in 1990, and dunkel is a style closely associated with Germany.

BACKGROUND

Dunkel was raised in Bavaria, the largest state in the German Republic, and still has a home there. It was also likely born there, with its first brewers believed to have been Bavarian monks of the late Middle Ages who made a dark lager that served as the prototype for what became dunkel. The style really started to come into its own, and to become richly entwined with Bavaria, after what

came to be called the Reinheitsgebot, the Bavarian beer purity law issued in 1516, went into effect and reduced brewing to hops, water, and barley (as yeast's role was not fully understood). At the time, there wasn't yet an effort toward the controlled roasting of malts, so every beer style was on the darker side, and the brown, slightly sweet, lightly bitter dunkel became the de facto lager style and everyday beer of Bavaria.

That popularity stayed steady at home and grew elsewhere nearby. This was especially true after the Spaten brewery—located in the Bavarian capital of Munich and run for much of the mid-nineteenth century by one of brewing's all-time great visionaries, Gabriel Sedlmayr II—perfected a continental roasting technology that left most dunkels exceptionally clear and smooth. It was Sedlmayr and Spaten who developed Munich malt, which would help define dunkel from the 1840s onward. The malt turned out to be perfect for paler lagers, producing a color that ranged from amber to honeyed yellow and a smooth sweetness that could offset any bittering hops.

That decade could have seen dunkel begin to conquer the beer world. Hundreds of thousands of Germans emigrated to North America, especially the United States, in the 1840s, taking a taste for dunkel with them. The problem was that dunkel's popularity just over the Bavarian border in what became Czechia unwittingly sparked the creation of pilsner.

Czechs were bitter about a foreign beer eating their own breweries' market share, so they came up with a competing style. That golden style edged out dunkel in popularity, including with German transplants in America who built brewing juggernauts like Anheuser-Busch and Miller to churn out pilsner rather than the dunkel of yore.

As it was, dunkel remained a Bavarian staple through the twentieth century. It found the occasional fan elsewhere but, even in its home region, helles and pilsner might have proven more popular in any given year (to be fair, pilsner was—and is—popular *everywhere*). It was not until dunkel's late 1970s embrace by Michael Jackson, and then the American craft brewers and fans who read his work, that the style enjoyed a widespread resurgence.

ABOUT THE NAME

Dunkel means "dark" in German and was an easy choice of name for the dark lager. You'll also run across dunkelweizens, which are dunkels made with a hefty share of wheat. They are yeastier and sweeter than regular dunkels, with a sharper undertone of fruitiness.

TRIVIA

That great Bavarian brewer of dunkel, Spaten, was also the site of the first test run of scientist Carl von Linde's artificial refrigeration machine in January 1874. That first test revealed

a fatal flaw: Linde's chosen refrigerant, methyl ether, leaked from a dodgy seal. This discovery at Spaten led to more tests, and Linde had a compressed ammonia refrigerator ready for patenting in early 1876. The millennia-long era of using blocks of ice, cool cellars, and even caves for brewing was over.[102]

HOW TO SAMPLE

GOOD EXAMPLES Nearly all the best examples are imports. Try Spaten's Dunkel, Bierstadt Lagerhaus's Dunkel, Weihenstephan's Weihenstephaner Hefeweissbier Dunkel, Modelo's Negra, and Warsteiner's Premium Dunkel.

TEMPERATURE Cool to cold.

LOOK FOR A dark brown pour without a lot of carbonation that ends with a thin but lasting head. A dunkel is neither a hoppy nor a bitter beer, but instead one that leans heavily on malty sweetness. There will be notes of chocolate and nuts, and maybe freshly baked bread. Because it's a lager, you get richness without heaviness. It's a clean, yet complex beer with an ABV between 4 and 6 percent.

SECOND WEEK OF OCTOBER
THIS WEEK'S STYLE

(ALTBIER)

WHY NOW?

Because we're keeping with a German theme for Oktober-fest, and altbier is a warming, German-born style ideal for the increasingly cooler fall days.

BACKSTORY

From the land that pioneered lagers comes a prototypical ale, altbier, which emerged as a distinct style in the nineteenth century, though it had likely existed in one form or another going back centuries. For years prior to altbier becoming a distinct style, "altbier" was the name for the copper-colored, dry, slightly fruity ale common in Düsseldorf and its surrounding region in the land that today is part of northern Germany.

Long Trail Ale is an excellent amber example of altbier.

Altbier's first heyday in the nineteenth century came as ale brewers looked for ways to compete with the popularity of other styles, first of English pale ales and then of pilsners from Bohemia in the Austrian Empire. Several settled on the malty beauty from Düsseldorf.[103]

As with most ales, altbier would never be able to compete with the golden, crisp pilsners that positively screamed modernity. Altbiers were old-school in both the figurative and literal sense. They were developed just before the modern brewing era and survived largely as a reaction to it, using old-fashioned brewing techniques and approaches.

By the end of the nineteenth century, altbier was still largely confined to the Düsseldorf region. It was one of those styles, such as kölsch out of Cologne, a little ways south, that was distinctly of its place. Still, it proved influential enough to draw the attention of American craft brewers by the end of the twentieth century, thanks in large part to Michael Jackson, who rightfully described altbier as "the German brew closest to a Belgian- or a British-style ale."[104] Today altbier thrives in Germany and other beery European lands, and serves as the model for many a copper-hued, hoppier ale in the United States.

ABOUT THE NAME

Alt means "old" in German. Thus, it's perfect for such an old-school style that harkens back to before the lighter lager rush.

TRIVIA

Many American beers labeled as "amber ales" for marketing purposes are actually altbiers, or at least the darker English pale ales that altbiers are akin to.

HOW TO SAMPLE

GOOD EXAMPLES There are a lot to choose from domestically, like Olde Mecklenburg's Copper Altbier, Long Trail Ale, Alaskan's Amber, and North Coast's Alt Nouveau.

TEMPERATURE Cool to cold.

LOOK FOR A copper to reddish pour with a sizzling, rocky head that lasts, and a smooth, caramel, hard-candy taste with a lingering floral finish followed by more than a hint of bitterness. This is a rewardingly complex style that's still light and clean enough to warrant a second or third (or fourth) helping. The alcoholic kick should not exceed about 6 percent ABV.

THIRD WEEK OF OCTOBER
THIS WEEK'S STYLE

BITTER

WHY NOW?

Because cozy fall weather is bringing more people indoors, and bitter arose in cozy British pubs and became the go-to style in those establishments.

BACKSTORY

If the English ever bury a time capsule to be opened a million years from now, it should include a bottle of bitter—or, better yet, a growler of it with a particularly firm seal. This is an English style straight out of central casting, yet the beer is ill-defined beyond the name itself.

Bitter had emerged as a distinct style by the end of the nineteenth century. It was a distant cousin of pale ale, with a larger share of hops for bittering, that came to be

the standard order in pubs throughout the country. It was often served straight from the keg without filtration or pasteurization, and only after a second fermentation in the keg, making bitter a solid example of what's known as "cask ale" or "real ale." This might have helped set the style apart from the catchall pale ale, and many traditionalists still hold that a proper bitter comes solely from the tap and never the bottle or can.

There are several contenders for who first made bitter available for commercial sale, on draft or otherwise, and they all grew into well-known names that rode the style's popularity into and through the twentieth century; among them Young's, Fuller's, Theakston, Timothy Taylor's, Marston's, Whitbread, and Shepherd Neame. Along the way, English brewers broke bitter into two categories: ordinary and best. An "ordinary" bitter will generally be lower in alcohol and perhaps thinner in taste, while a "best" bitter is stronger and fuller-tasting.

The Campaign for Real Ale (CAMRA), a grassroots movement started in the United Kingdom in 1971 to rescue traditional brewing and styles, embraced bitter in particular. To CAMRA members, it had to be served as "real ale" (it was in the group's name), which meant that it was made with traditional ingredients and by traditional methods and, crucially, that its final fermentation occurred in the vessel from which it was served. That is, no further

preservation or pasteurization could take place as part of a bottling process—it goes straight from a keg or cask into a glass. Some might have found the fastidiousness of this off-putting, but the devotion to bitter from the cask bolstered the style into the twenty-first century. That's when some American craft brewers tried to run with it. But bitter remains English, and "a pint of bitter" is still a standard order in UK pubs.

ABOUT THE NAME

By the late nineteenth century, any British pub worth its salt carried two different sorts of beer, and any brewery of similar reputation made the same: a mild and a bitter. The mild was generally sweeter, and the bitter was a hoppier choice. Some breweries forewent the "best" label and labeled their heftier bitter option "special" or "extra special" instead. Extra special bitters (ESBs), in particular, survive as a familiar feature of American craft beer, as a few craft breweries took up the nomenclature for their brands.

TRIVIA

Four young friends from northwest England—three journalists and an office worker at a brewery—founded the Campaign for Real Ale while vacationing in western Ireland in March 1971.[105] They were sitting around Kruger's Bar—a pub at the

end of the Dingle Peninsula that is supposedly Europe's westernmost bar, if you don't count those in Iceland—and complaining about the quality of the beer back home. Their idea led to not only the successful consumer organization, but also the Great British Beer Festival, which was first held in September 1977 in London. That festival inspired the organizers of the Great American Beer Festival, which debuted in Boulder, Colorado, in 1982.[106]

HOW TO SAMPLE

GOOD EXAMPLES Fuller's London Pride, Fuller's ESB, Samuel Smith's Old Brewery Bitter, and Timothy Taylor's Boltmaker are all rock-solid examples from the old country. American iterations include Redhook's ESB, Yards's Extra Special Ale, and Ipswich's Original Ale.

TEMPERATURE Warm to room. Bitter is one of the few styles where warm is desirable, as it brings out the beer's flavors and aroma.

LOOK FOR A color that ranges from bronze to copper and could be pale, but never golden. There should be a slight aroma reminiscent of freshly-baked bread and a thin head that dissipates quickly but that still leaves foamy lace on the glass. What should follow is a light body with a dry, full

bitterness balanced by hints of malty sweetness on the finish. The ABV is likely no more than 6 percent (though many ESBs, specials, and bests do run higher).

PUMPKIN ALE

WHY NOW?

Because pumpkins are peaking in popularity just in time for Halloween. Everything else is pumpkin-flavored right now, so why not lean into it?

BACKSTORY

People have been brewing beer with pumpkin pulp for centuries. The fruit's fibrous innards make for a brothy-smelling mash, with plenty of sugars for the yeast to convert into ethanol. Pumpkin ale is not the most sessionable of beers—meaning a lower-alcohol, more easily drinkable style you can enjoy more than one or two of during a night out (or in)—but it's an enduringly popular seasonal, in large part

because of the continuous popularity of all things pumpkin come October.

The modern pumpkin ale was first made in the mid-1980s at one of America's earliest post-Prohibition brewpubs, Buffalo Bill's Brewery in Hayward, California—a brewery that serves its beers on site with a little food available too. Bill Owens, a noted photographer and serial entrepreneur, founded the brewery in 1983, using the space of an old camera store. Owens had brewed his own beer throughout the 1970s, a time when the hobby was technically illegal at the federal level. This would change in 1978 following a push by enthusiasts in California and their political allies, and it was that same year, on Owens's fortieth birthday, that a friend jokingly suggested he start his own brewery. Owens later asked his accountant how he might get a loan for such a pie-in-the-sky idea. Who was crazy enough to start a brewery when Anheuser-Busch and Miller were putting everyone else out of business? The accountant reached into his desk drawer, pulled out a form meant for another client, and said, "White out 'almond farm' and put in 'brewery.'" The bean counter proposed a limited partnership, and Owens embarked on creating Buffalo Bill's Brewery.[107]

The idea for a pumpkin ale came from research into the quirkier ways Americans had made beer. It also sprung from the fact that tiny operations such as Buffalo Bill's could experiment in ways that bigger breweries could not.

(Owens's brewpub also produced what might have been the first post-Prohibition strawberry-flavored ale for sale in America.)

At first, Owens used the innards of pumpkins he grew himself, but the mash came off as rather vegetal, so he grabbed some pumpkin pie mix at a nearby grocery store and blended it until it was juicy. That turned the final product into something spicy and sweet. Owens then started selling glasses of what he called "Punkin Ale" at the front of Buffalo Bill's.

Others in craft beer would also create their own pumpkin ales, probably most prominently Delaware's Dogfish Head with its 1995 Punkin Ale release. The niche really bloomed in 1997 when Blue Moon, a subsidiary of the brewing giant then called MillerCoors, released a pumpkin ale. The style became an early fall staple thereafter.

ABOUT THE NAME

It's from the starring ingredient, whose name likely derives from the Latin word *peopnem*, meaning "melon." What Americans think of as a pumpkin is actually an indigenous squash that was unknown to Europeans prior to their arrival in Massachusetts, where the native people used the curiously similar word *pôhpukun*, meaning "grows forth round."[108] It's a case of two things coming together, like pumpkin and beer.

TRIVIA

Bill Owens would say that his interest in pumpkin ale was piqued by the discovery that George Washington used squash and pumpkins in brewing beer at Mount Vernon, Washington's Virginia estate.[109] The remark appeared to spur decades of anecdotes about Washington brewing this or that pumpkin ale or squash lager. Some brewers have even claimed to have recreated the original recipe with their releases. However, there is no evidence that Washington's estate brewed with pumpkins or squash, according to the Mount Vernon trustees.[110] That said, Washington was famously a fan of beer, one of the primary beverages for people of all ages in colonial and post-Revolution America, and hops were grown at Mount Vernon starting in 1785, fourteen years before the founder's death.

HOW TO SAMPLE

GOOD EXAMPLES For a great Halloween activity, try a variety of pumpkin ales and settle in on your favorite. Ones worth trying include Dogfish Head's Punkin Ale, Shipyard's Pumpkinhead Ale, Southern Tier's Pumking Imperial Ale, Saint Arnold's Pumpkinator, and Harpoon's UFO Pumpkin Ale.

TEMPERATURE Cool to cold.

LOOK FOR A pour of dark copper to red, with a rocky, lasting head. As you might expect, a good pumpkin ale should be savory and sweet with a cinnamon spiciness. The pumpkin should come through in the rich mouthfeel but should not be overpowering. This is not necessarily a fruit-infused beer in the manner of kriek or framboise; instead, it's heavier and lusher, almost a dessert beer. Depending on the brewery, the ABV can run from 4 percent to nearly 10 percent.

WHEN MICHAEL MET BERT . . .

It's the stuff of legends, but it's true. Bert Grant used to tool around the sharp peaks and lush valleys of the Pacific Northwest in a Rolls Royce with the license plate "REAL ALE," and the beer critic Michael Jackson rode shotgun sometimes. It was during one of the Englishman's trips stateside, just after Grant had incorporated his Yakima Brewing and Malting Company in 1981, that Jackson and Grant discussed the brewpub's very first offering: a Scotch ale.

"Isn't this on the hoppy side for a Scotch ale?" Jackson asked.

"Yes," Grant answered. "All beers should be hoppier."

Grant, who died in 2001, would gain fame for introducing the first new post-Prohibition India pale ale in the United States to explicitly label itself as such. But Jackson had a point: Scotch ales were supposed to be all about the malty sweetness, not the hoppy bitterness.

"Is it fair to sell it as a Scotch ale?" Jackson pressed.

"It is Scotch ale because I created it," Grant said. "I am Scottish."

"When did you leave Scotland?" Jackson asked.
"When I was two years old."[111]

THIS WEEK'S STYLE

RAUCHBIER

WHY NOW?

Because it's a smoky style to warm the early days of fall as fire festivals around the world, like Guy Fawkes Night in the United Kingdom, welcome the cooler, crunchier season.

BACKSTORY

Rauchbier emerged in and around the small northern Bavarian city of Bamberg in the sixteenth century. A dry, burnt, and therefore smoky taste of beechwood defines the style. All beers before the emergence of modern grain-kilning techniques had a toasted taste to a degree, but by the mid-nineteenth century such a taste had become entirely optional for brewers. It was only then, still in and around Bamberg, that rauchbier started to come into its own.

Why Bamberg? By all rights, the Bavarian city should be another paradise of märzen, dunkel, and weissen; however, it's more closely associated with rauchbier. One possible reason for this is that Bamberg and its surrounding region boast forests of beech, along with oak (the primary wood for roasting malt and wheat to forge that distinctive rauchbier taste). But other areas of Germany host beech forests, as does a lot of Europe, so this wouldn't offer a complete explanation. Another possibility is that because of the ready supply of beechwood, the region's several smaller independent breweries were brewing rauchbier long before it was considered a distinct style. These two theories appear to have fused by the late twentieth century to anoint Bamberg as the nexus of rauchbier. Michael Jackson—as renowned an expert on whiskey as he was on beer—compared the beechwood-smoked beers of Bamberg with the peat-fired single malts of Scotland's Islay island. "In each instance, a traditional method has been retained to produce a distinctive local specialty," Jackson wrote in *The World Guide to Beer*.[112]

Bamberg's local specialty became an international presence with Jackson's help and took especial hold in the United States, where craft brewers began embracing the smoky, oaky approach in the 2000s as a kind of drier foil to the rise of super-lush India pale ale.

ABOUT THE NAME

Rauch means "smoke" in German. The descriptor is a nod to the smoky taste and aroma that the brewing techniques behind the style produce.

TRIVIA

Franconia is a region of Germany that encompasses much of northern Bavaria, where Bamberg is located, as well as swaths of neighboring German states. Franconia had the most breweries of any region in the world until the twentieth century. Today, following the rise in craft breweries, various US states and regions—especially California and the Pacific Northwest—have overtaken it in brewery count.

HOW TO SAMPLE

GOOD EXAMPLES A rauchbier is generally a lager, though some key exceptions include smoked porters. Aecht Schlenkerla Rauchbier is a märzen from Franconia, Switchback in Vermont has a smoked saison called Bisou, and Fox Farm in Connecticut has a smoked helles named The Cabin. Stone's Smoked Porter is more widely available. Probably the best example domestically (and perhaps one of the best beers ever made in America) is Alaskan's Smoked Porter.

TEMPERATURE Room to cool.

LOOK FOR Rauchbiers generally pour on the reddish-brown to dark brown side, and the heads are similar in buoyancy and endurance to heavier ale styles such as barley wine and Scotch ale. Unsurprisingly, a roasted aroma and taste dominate, whatever the style that's been smoked. There should be a savory bone-dryness on the finish with little in the way of sweetness. The alcohol content can vary widely.

SECOND WEEK OF NOVEMBER
THIS WEEK'S STYLE

WHY NOW?

Because dubbel is a great style in its richness and depth for the longer, colder nights. It's also a style closely associated with the region of Flanders in Belgium. The second week of November includes Remembrance Day (or Veterans Day in the US), which evolved from Armistice Day and are held on November 11 to commemorate the end of World War I. That global conflict saw much of its worst fighting in Flanders.

BACKSTORY

The rich, brown dubbel style was born roughly in the late nineteenth century in the Trappist monastery Westmalle, located in the northern Belgian region of Flanders, where

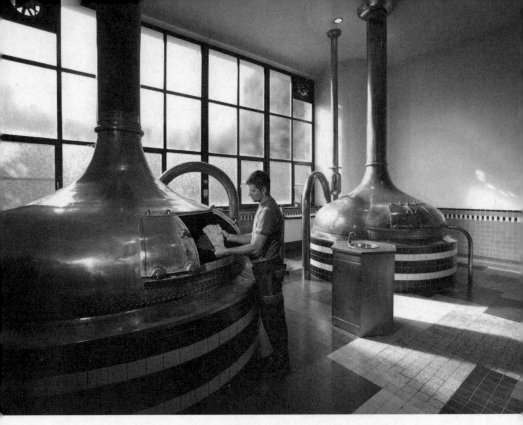

The brewhouse at Westmalle.

by the 1860s the monks were producing a brown ale for their own consumption. It was a rustic, uneven affair, with the recipe shifting and the quality sometimes iffy. By the 1920s, seeking to rebuild and rejuvenate following the Great War, the monks brought in a consultant named Hendrik Verlinden and together they zeroed in on that everyday brown ale as a possible, albeit modest, money-maker. Verlinden and the monks smoothed out the beer's

body, upped its alcohol content with candi sugar, and began selling the finished product locally. Dubbel was a commercial product by the end of the 1920s and would evolve through the next several decades, with every iteration linked to that Westmalle offering. You can still visit the charmingly home-spun Westmalle monastery to sample its beers, including dubbel. Dubbel would probably have remained a speck in the history of Belgian brewing were it not for Michael Jackson's highlighting of it in the 1970s. By the 1990s, it was not un-usual to find dubbels on the shelves, and very occasionally the taps, of specialty shops and bars in the United States. That presence proliferated with the rise of craft beer culture.[113]

ABOUT THE NAME

The name "dubbel" likely comes from the Dutch word *dubbel*, meaning "double." (Much like how *tripel*, the name for another style Westmalle pioneered, likely comes from "triple.") The use of "double" is meant to denote the style's alcoholic kick relative to other beers in the Trappist repertoire. That said, concern with a beer's alcoholic strength is a fairly modern obsession born in large part of government regulations that didn't exist when styles like dubbel were first developed. Verlinden and the monks a century ago focused instead on the color of the style—*dubbel bruin* or "double brown."

TRIVIA

Henrik Verlinden's De Drie Linden brewery in Flanders released the first commercial tripel in 1932, only a few years after he steered the monks of Westmalle to the first commercial dubbel. Verlinden was a versatile force in Belgian brewing and distilling, his initial area of expertise. Among his achievements was the first book in Flemish that took a scientific approach to yeast, according to critic Stan Hieronymus. A German bomb struck his brewery during the Second World War, killing him.[114]

Perhaps in recognition of his contributions to Trappist beer, the Trappist breweries—normally very litigious when it came to copyright—allowed Verlinden and his family to call their brewery's wares "Trappistenbier" into the 1980s.

HOW TO SAMPLE

GOOD EXAMPLES Save these generally expensive brews for a special occasion, or for a very deserved treat: Westmalle's Dubbel, St. Bernardus's Prior 8, Brasserie de Rochefort's Trappistes Rochefort 6, Unibroue's Maudite, and Ommegang's Abbey Ale.

TEMPERATURE Room to cool.

LOOK FOR A foamy pour settling in as brown to red, with a rocky, lasting head. The first tastes are of caramel and chocolate, maybe dried apricot and plum, with light bitterness on the finish. A good dubbel will also be on the savory side, creamy, and almost sweet on the finish (and obviously complex). Look for an alcoholic kick of 7 to 9 percent ABV.

DORTMUNDER

WHY NOW?

Because dortmunder pairs very well with turkey, and Thanksgiving is upon us.

BACKSTORY

In November 1983, Michael Jackson wrote a classic piece for the *Washington Post* on the best beers to pair with Thanksgiving dinner. It was a major milestone in recognizing beer as more than just a watery refreshment to have while watching the football game on the great feast day; instead, it deserved a place at the table. Jackson's verdict? To go with a "pale but medium dry brew of the type produced in the city of Munich and elsewhere in Bavaria ... [that] have plenty of body without being too filling."[115]

Today, such "Munich light beers," as Jackson described them, barely exist anymore, even in Germany. And the context of "light beer" has changed quite a bit since 1983. For a similarly dry lager that won't sit too heavily on your stomach (a necessity given all the turkey, stuffing, and potatoes we consume), go north of Munich to Dortmund.

The Dortmund area until about the 1970s was the biggest German fount of beer—maybe the biggest in Europe—and its main style was dortmunder. The pale lager developed in the middle to late nineteenth century, largely as a reaction to the sharp rise of pilsner. Dortmunder was slightly heavier than pilsner, with a maltier backbone.

Compared with other darker lagers of the time—think Bavaria's dunkel—paler, lighter-tasting dortmunder seemed positively revolutionary for German lager. For a time it reigned as a robust national answer to the Czech-born pilsner. Jackson, writing in the original *World Guide to Beer* in 1977, described the brewing juggernaut that was the style's hometown: "It is barely possible to leave the railway station without encountering a cluster of Dortmund breweries."[116]

The Dortmund hub was already past its production peak when Jackson typed those words, and the style would cede the marketplace to pilsner by the century's close. Jackson's scribbling, however, kept dortmunder alive outside

of Germany, and American craft brewers in particular have experimented with the style ever since.

ABOUT THE NAME

"Export" or "dortmunder export" is often used interchangeably with *dortmunder*, or "the beer of Dortmund." "Export" grew from the spread of a slightly fuller dortmunder to areas beyond the city. The two are not necessarily synonymous, but export and dortmunder are very similar and the former is much more commonly sold than the latter.

TRIVIA

Why was Dortmund such a hotspot for brewing? It was a major center for the coal and steel industries as the future German Empire began industrializing in the last few decades of the nineteenth century. This not only aided the creation of large-scale breweries but also provided a thirsty consumer base among workers relocating to the city from farmland. Dortmund was also the birthplace of a now largely extinct style of sour-tasting ale called adambier.

HOW TO SAMPLE

GOOD EXAMPLES Domestic brands offering dortmunder are still limited, though growing. International ones are more common and their dortmunder offerings are often not hard to find in the United States. Try Great Lakes's Dortmunder Gold Lager, which is brewed in Ohio; for German options, try Ayinger's Jahrhundert Bier or DAB's Dortmunder Export or Kronen Export.

TEMPERATURE Cold.

LOOK FOR Not surprisingly, a beer that rose as a competitor to pilsner pours bright and nearly golden, with lots of carbonation and a foamy, buoyant head. There should also be a nice, malty sweetness and a mild, not overwhelming bitterness for balance. Overall, dortmunder is a sessionable beer that should be light on the belly with an ABV that is usually no more than 6 percent—perfect for Thanksgiving.

FOURTH WEEK OF NOVEMBER
THIS WEEK'S STYLE

(SCOTCH ALE)

WHY NOW?

Because November 30 is St. Andrew's Day, a major national holiday in Scotland, the style's birthplace.

BACKSTORY

Scotch ale was born in Scotland in the late eighteenth century around the same time as barley wine was born in England, and the two styles share many characteristics, including being more malty than hoppy. Scotch ale is higher in alcohol than your average beer, and its color runs from ruby red to deep mahogany.

Scotch ale differs from barley wine in subtle ways that underscore its origins. For example, while both are more malty than hoppy, Scotch ale is even maltier than barley

wine, which has some hoppy bitterness on the finish. A good Scotch ale will have little to no hoppy bitterness. That's because the earliest purveyors of the style did not have ready access to hops, whereas English brewers did. The maltiness likely came from the eighteenth-century practice of roasting barley in kilns powered by burning peat, a ready source of heat in Scotland for centuries. This imparted a smoky, toasty element to the style that became Scotch ale. It did the same thing for Scotland's famed whiskys.

It's unknown which brewery was the first to label its ale "Scotch ale," though brewers were exporting beers with the style's characteristics by the 1750s, including to North America. It would be there in America that Scotch ale would truly enjoy a renaissance more than 200 years later. American craft brewers embraced the warm, velvety style and made it their own beginning in the 1980s.

ABOUT THE NAME

Scotch ale refers to a particular style and should not be confused with "Scottish ale," a catchall for all ales that originated in the country of kilts and lochs. Scotch ale is occasionally called "wee heavy," a nickname that probably started as late as the twentieth century. The "heavy" refers to the alcoholic strength, and the label was used to indicate that Scotch ale was a strong ale.

TRIVIA

Some brewers, including but not limited to those in Scotland, priced beer according to the intensity of its malt in the eighteenth and nineteenth centuries. Lighter ales cost fewer shillings, whereas heavier ales cost much more. An especially thick and rich Scotch ale could command a price of over 120 shillings.[117]

HOW TO SAMPLE

GOOD EXAMPLES Oskar Blues' Old Chub is one of the best and most widely available American-made Scotch ales. Duck-Rabbit Craft Brewery in North Carolina has long specialized in dark beers and, appropriately enough, releases its Wee Heavy Scotch Style Ale in time for winter.

TEMPERATURE Room temperature.

LOOK FOR Velvety malt and bracing alcohol should be up front in any Scotch ale. The pour will leave a dense, lasting head and have an almost opaque copper color. Don't anticipate too much hoppy bitterness or effervescence. This is another meal-in-a-glass type beer with a sweet, malt-forward taste. The alcoholic kick can reach 10 percent ABV and beyond.

AUTHOR'S NOTE

I returned to two works in particular over and over again while writing this book. Michael Jackson's updated *World Guide to Beer* from 1988, which included a lot of historical and descriptive information on many—though not all—of these styles. And the *Oxford Companion to Beer* from 2012, which served as a double-check on Jackson's work where possible.

I also culled from my own research for a pair of books I wrote in the 2010s—*The Audacity of Hops*, which was a history of American craft beer until 2017, and *PILSNER*, a history of the most popular beer style—and from regular columns I wrote for the defunct blog *Food Republic* and *All About Beer* magazine, which in 2022 was happily resurrected. My books included a lot of research into Jackson's life and writing, which I culled from too (for instance, it was Jackson's longtime partner who told me the critic couldn't stand Corona in particular). Those earlier books involved interviews with numerous brewery founders and brewmasters, the very people who crafted the modern versions of the styles mentioned in *this* book. The columns relied on original research that included interviews with principals and brewers at breweries. If I do not cite sources for particular information in entries, readers should assume the information came from research

for my previous work. I have noted, where it may not be too repetitious, where to find that information.

I am also indebted to Stan Hieronymus's *Brew Like a Monk* and Jackson's *Great Beers of Belgium* for insight on the Belgian and Belgian-inspired styles herein. Beer criticism is of course subjective; but I didn't want to stray too far from what others might taste in these styles. So the Brewers Association's style guidelines and those of the Beer Judges' Certification Program served as quick references to check against my own tastings. Any information about release dates of beers and brands are based on the breweries' own information from their websites, emails with brewers and owners, or corporate communications.

Finally, I thank my family, especially my wife, Elizabeth, for her ceaseless support, and my father-in-law, John Rudy, for his always astute proofreading. I thank, too, the team at Apollo Publishers, including Drew Anderla, Julia Abramoff, Emily Epstein White, Maeve Norton, Audrey Stewart, and Philip Verdirame, and my agent, Adam Chromy, who brought me the initial idea for this book. It was a bear to put together due to the many changes in the industry and the marketplace since the pandemic started in 2020. I hope it helps readers to make better sense of things and to add a little more enjoyment to their lives.

PHOTO CREDITS

Page 1, © Brewers Association.

Page 3, Courtesy of Paddy Gunningham and Samantha Hopkins.

Page 12, Courtesy of Duvel Moortgat Brewery.

Page 30, Courtesy of the Anchor Brewing Company.

Page 37, Courtesy of Rightside Brewing.

Page 40, Courtesy of Rogue Brewery.

Page 47, Courtesy of Rightside Brewing.

Page 64, Courtesy of Merchant du Vin.

Page 66, Courtesy of Merchant du Vin.

Page 78, Courtesy of the Anchor Brewing Company.

Page 88, The Boston Beer Company, Boston, MA. Used with permission.

Page 95, Courtesy of the Stone Brewing Company.

Page 108, Courtesy of the Alchemist Brewery.

Page 113, The Boston Beer Company, Boston, MA. Used with permission.

Page 129, Courtesy of Mass Bay Brewing Co.

Page 130, Courtesy of Mass Bay Brewing Co.

Page 148, Alexander Baranov, 2012, under Creative Commons Attribution 2.0 Generic license, https://commons.wikimedia. org/wiki/File:File_by_Alexander_Baranov_-_IMG_8423_ (14140479664).jpg#metadata.

Page 151, wrangle / © iStock

Page 154, Courtesy of Merchant du Vin.

Page 167, Courtesy of Duvel Moortgat Brewery.

Page 173, Courtesy of Rogue Brewery.

Page 181, Courtesy of the Alchemist Brewery.

Page 192, Courtesy of Duvel Moortgat Brewery.

Page 195, Courtesy of Duvel Moortgat Brewery.

Page 196, Courtesy of Duvel Moortgat Brewery.

Page 201, Courtesy of the Stone Brewing Company.

Page 210, Courtesy of Mass Bay Brewing Co.

Page 214, Courtesy of Molson Coors Milwaukee Archives.

Page 228, Courtesy of Sierra Nevada Brewing Co.

Page 237, Courtesy of Anchor Brewing.

Page 247, The Boston Beer Company, Boston, MA. Used with permission.

Page 255, Courtesy of Mass Bay Brewing Co.

Page 275, Courtesy of Merchant du Vin.

Page 307, Author photo by Saadia Sumrall.

NOTES

1 Livia Gershon, "Remains of 9,000-Year-Old Beer Found in China," *Smithsonian Magazine*, September 2, 2021, https:/www.smithsonianmag.com/smart-news/remains9000year-old-beer-found-china-180978563/.

2 Garrett Oliver, "Jackson, Michael," *The Oxford Companion to Beer* (New York: Oxford University Press, 2012), 501.

3 The English comedian Eric Idle of *Monty Python* fame cast the bluntest stone with the joke: "We find your American beer like making love in a canoe. It's fucking close to water." *Monty Python Live at the Hollywood Bowl*, directed by Terry Hughes and Ian MacNaughton, Python (Monty) Pictures and Hand-Made Films, 1982, DVD.

4 The biographical information for Jackson is sourced from the author's research for his book *The Audacity of Hops: The History of America's Craft Beer Revolution*, 2nd ed. (Chicago: Chicago Review Press, 2017).

5 Daniel J. Leonard, "Michael Jackson and the Origin of Beer Styles," *The Beer Syndicate Blog*, November 22, 2016, https://beersyndicate.com/blog/michael-jackson-and-the-origin-of-beer-styles/ (accessed November 1, 2022); Jeff Alworth, "Who Arranged Beer Into Styles?," *Beervana*, August 31, 2021, https://www.beervanablog.com/beervana/2021/8/30/who-catalogued-beer-into-styles (accessed November 1, 2022).

6 Brewers Association, "National Beer Sales & Production Data," Brewers Association (website), https://www.brewersassociation.org/statistics-and-data/national-beer-stats/. Stats on style categories can be found through the BA's Great American Beer Festival portal at https://www.greatamerican-beerfestival.com/.

7 The Michael Jackson *Beer Hunter* archive, maintained through the UK's Oxford Brookes University, provides a trove of writing from the writer and critic. This quote came from an introduction to the "Beer Culture" section, https://sites.google.com/brookes.ac.uk/beer-hunter/home/beer-culture.

8 Stan Hieronymus, *Brew Like a Monk: Trappist, Abbey, and Strong Belgian Ales and How to Brew Them* (Boulder, Colorado: Brewers Publications, 2005), 71–72; Michael Jackson, *The Great Beers of Belgium*, rev. ed. (Antwerp: Media Marketing Communications, 2001), 241–243.

9 Ibid.

10 Derek Walsh, "Tripel," *The Oxford Companion to Beer*, 798–799.

11 Jackson, *The Great Beers of Belgium*, 242.

12 Martyn Cornell, "Today Is 299 Years Exactly Since the First Known Mention of Porter," *Zythophile* (blog), May 22, 2020, https://zythophile.co.uk/2020/05/22/today-is-299-years-exactly-since-the-first-known-mention-of-porter/.

13 The English craft brewery Anspach & Hobday worked with Martyn Cornell on an exhaustive rundown of porter's origins. It could be found here as of December 20, 2022: https://www.anspachandhobday.com/blog/porter-history.

14 Martyn Cornell, "The Forgotten Story of London's Porters," *Zythophile* (blog), November 2, 2007, https://zythophile.co.uk/2007/11/02/the-forgotten-story-of-londons-porters/.

15 Washington's correspondence is preserved in an easily searchable format by the National Archives at https://founders.archives.gov/. For examples, see "Invoice to Robert Cary & Company," September 20, 1759, and "Invoice from Richard Washington," August 20, 1757.

16 Horst Dornbusch and Garrett Oliver, "Porter," *The Oxford Companion to Beer*, 662–664.

17 Tom Acitelli, "A Brief History of American-Made Christmas Beer," *All About Beer*, 2011, https://allaboutbeer.com/american-christmas-beer-history/.

18 Ibid; Don Russell, *Christmas Beer: The Cheeriest, Tastiest and Most Unusual Holiday Brews* (New York: Universe, 2008).

19 Author's email exchange with Don Russell, April 24, 2014.

20 Vince Cottone, *Good Beer Guide: Breweries and Pubs of the Pacific Northwest* (Seattle: Home-stead Book Company, 1986), 9–15.

21 "A High Tech Beer From Silicon Valey," *New York Times*, November 15, 1983, D5; Bryan Miller, "An Effort to Revive New York Beer (in Utica For Now)," *New York Times*, June 29, 1983, C1.

22 Steve Hindy, interview with the author, September 9, 2010; "Association of Brewers and BBA to Merge," *Modern Brewery Age*, October 11, 2004; Daniel Bradford, interview with the author, September 30, 2011.

23 Brewers Association, "Brewers Association Releases Annual Growth Report," Press Release, April 2, 2019, https://www.brewersassociation.org/press-releases/brewers-association-releases-annual-growth-report/.

24 Solcyré Burga, "The Origins of Dry January," *Time*, January 4, 2004, https://time.com/6552262/dry-january-origins-alcohol-drinking/.

25 Stanley Baron, *Brewed in America: A History of Beer and Ale in the United States* (Boston & Toronto: Little, Brown & Company, 1962), 312–314.

26 Brewers Association, 2023 GABF Entries, https://cdn.greatamericanbeerfestival.com/wp-content/uploads/GABF23-Winners-List.pdf.

27 Ernest K. Lindley, *The Roosevelt Revolution: First Phase* (New York: The Viking Press, 1933), 91. Special thanks to the

Franklin Delano Roosevelt Presidential Library and Museum in Hyde Park, New York, for helping track down this quotation from one of FDR's dinner guests that night.

28 Anonymous, "Chapter 19," *The London and Country Brewer* (1736, last modified April 30, 2013), via Project Gutenberg, gutenberg.org/files/8900/8900-h/8900-h.htm.

29 Dick Cantwell, "Barley Wine," *The Oxford Companion to Beer*, 93.

30 Christina Perozzi, "From Church Key to Pop Top, a Look Back at Canned Beer," *Eater*, July 15, 2015, https://www.eater.com-drinks/2015/7/15/8942369/dirt-cheap-week-canned-beer.

31 US Internal Revenue Code §5052 - Definitions, sourced through Cornell Law School's Legal Information Institute website, https:/www.law.cornell.edu/uscode/text/26/5052.

32 Tony Magee, unpublished, unpaginated memoir manuscript, shared with the author in late 2011. The memoir would be published by Charles Pinot in November 2012 as *The Lagunitas Story* and reissued two years later by the Chicago Review Press as *So You Want to Start a Brewery: The Lagunitas Story*. The Oregon Brew Crew confirmed the existence of the thread, though the author himself did not see it.

33 Jackson, *The Great Beers of Belgium*, 83.

34 Ibid.

35 Fritz Briem, "Berliner Weisse," *The Oxford Companion to Beer*, 125.

36 Michael Jackson, *The New World Guide to Beer* (New York: Running Press Book Publishers, 1988), 62–63.

37 Fritz Briem, "Berliner weisse," *The Oxford Companion to Beer*, 124.

38 Michael Jackson, "Champagne of the North," *World Guide*, 62.

39 Briem, 124.

40 Conrad Seidl, "Doppelbock," *The Oxford Companion to Beer*, 294.

41 Jackson, *The New World Guide to Beer*, 52.

42 Brian Glover, "Imperial Stout," *The Oxford Companion to Beer*, 480; Cornell, "Albert Le Coq Is NOT a Famous Belgian," *Zythophile* (blog), October 3, 2017, https://zythophile.co.uk/2017/03/10/albert-le-coq-is-not-a-famous-belgian/.

43 Michael Jackson, "The Birth of Lager," *All About Beer*, March 1, 1996. Available via "Michael Jackson: the Beer Hunter" internet archive, https://sites.google.com/brookes.ac.uk/beer-hunter/home.

44 Pete Slosberg, *Beer for Pete's Sake: The Wicked Adventures of a Brewing Maverick* (Boulder, CO: Brewers Publications, 1998), 3–27; Pete Slosberg, interview with the author, March 5, 2012; Mark Bronder, interview with the author, February 27, 2012. Bronder also cofounded Pete's Brewing Company.

45 Tom Miller, "This Brew's for You," *Arizona Trend*, January 1989, 75.

46 Kelly Phillips Erb, "You can thank excise taxes for Guinness stout," *Forbes*, March 17, 2016, www.forbes.com/sites/kellyphillipserb/2016/03/17/you-can-thank-excise-taxes-for-guinness-stout/ (accessed November 18, 2022); Martyn Cornell, "Imperial stout — Russian or Irish?", *Zythophile*, June 26, 2011, zythophile.co.uk/2011/06/26/imperial-stout-russian-or-irish/ (accessed November 18, 2022); Jeff Alworth, "All styles evolve: The Guiness example," *All About Beer*, August 16, 2016, allaboutbeer.net/styles-evolve-guinness-example/ (accessed November 18, 2022).

47 Lester Black, "Pike Brewing turns 30, meaning it's time to say thank you," *The Stranger*, October 17, 2019, www.thestranger.com/slog/2019/10/17/41720350/pike-brewing-turns-30-meaning—its-time-to-say-thank-you (accessed November 18, 2022).

48 Jackson, *World Guide*, 242-243; Brian Yaeger, "Japanese-style rice lagers are the latest frontier of Pacific North-west craft brewers," *Portland Mercury*, March 25, 2022.

49 Ibid.

50 Jackson, *The New World Guide to Beer*, 192.

51 Jim Koch, interview with the author, July 21, 2011.

52 Ian S. Hornsey, *A History of Beer and Brewing* (London: Royal Society of Chemistry, 2003), 625–626.

53 Rob Burton, *Hops and Dreams: The Story of Sierra Nevada Brewing Company* (Chico, CA: Stansbury Publishing, 2010), 186; Ken Grossman, email message to the author, July 2012; Tom Acitelli, "Sierra Nevada Pale Ale: A Cascading Effect," *All About Beer*, September 1, 2015.

54 Conrad Seidl, "Helles," *The Oxford Companion to Beer*, 430.

55 Ibid.

56 Ibid.

57 Karl-Ullrich Heyse, "Kölsch," *The Oxford Companion to Beer*, 519; Tom Acitelli, "Kölsch: Where Ale Meets Lager," *Food Republic*, June 11, 2015; Jackson, *The New World Guide to Beer*, 64–66.

58 William Least Heat-Moon, "A Glass of Handmade," *Atlantic Monthly*, November 1987, 260.

59 "National Beer Sales & Production Data," Brewers Association, accessed Aug. 12, 2024, https://www.brewersassociation.org/statistics-and-data/national-beer-stats/.

60 Leah Dienes and Dibbs Harting, "Kentucky Common: An Almost Forgotten Style," presentation to the Beer Judges Certification Program, https://legacy.bjcp.org/docs/NHC2014-kycommon-handout.pdf. The author thanks Ms. Dienes for information about the paper's release. Her and Harting's research into Kentucky common peeled away a lot of the myth surrounding the style.

61 Conrad Seidl, "Bock Beer," *The Oxford Companion to Beer*, 138.

62 Rick Steves, *Luther and the Reformation*, 2016 documentary

video special, https://www.ricksteves.com/tv-programmers/specials/luther, 55:37.

63 Jackson, *The New World Guide to Beer*, 169.

64 Author's email exchange with Camilla Weddell of CAMRA, October 21, 2022.

65 Pete Brown, "Josef Groll," *The Oxford Companion to Beer*, 209.

66 Michael Jackson, "Pure Genius, Threatened by Folly," *The Independent*, January 16, 1993.

67 Jay C. Williams, "Behind the rise of Mexican-style lagers," *Wine Enthusiast* (website), September 17, 2018, https://www.wineenthusiast.com/culture/spirits/mexican-style-lagers/ (accessed November 30, 2022).

68 Aliza Kellerman, "The Mexican cerveza you know is actually European," *Vine Pair*, April 29, 2015, https://vinepair.com/wine-blog/why-the-cerveza-you-know-is-actually-european/ (accessed November 2022).

69 Jonathan Andrade, "Crisp, refreshing Mexican lagers are finally getting their due," *Washington Post*, June 9, 2022, https://www.washingtonpost.com/food/2022/06/09/mexican-lagers-lat-in-owned-breweries/.

70 Kellerman, "The Mexican cerveza."

71 Indeed, Duvel started out as a darker-colored ale. Keith Villa and Ben Vinken, "Duvel Moortgat," *The Oxford Companion to Beer*, 313.

72 William Brand, "Duvel packs a devilish punch," *Bay Area News Group*, September 20, 2006. The quotation is noted in one way or another in various other sources, including Jackson's *Great Beers*.

73 Alicia Wallace, "Yes, They Can," *Boulder Daily Camera*, April 18, 2010.

74 John Holl, "Podcast Episode 26: Sierra Nevada's Ken Grossman: The Latest Trends," *Craft Beer & Brewing*, March 23, 2018.

75 Kate Bernot, "How the Hazy New England IPA Conquered

America," *Thrillist*, April 10, 2018, https://www.thrillist.com/drink/nation/new-england-ipas-best-beer-style.

76 Author's email exchanges with John Kimmich, December 2022.

77 Michael Kiser, "The Crown That Sits Atop Heady Topper," *Good Beer Hunting* (blog), September 8, 2016, https://www.good-beerhunting.com/blog/2016/9/8/unrated-the-crown-that-sits-upon-heady-topper.

78 Phil Markowski, "Biere de Garde," *The Oxford Companion to Beer*, 126-127.

79 Ibid.; Jackson, *World Guide*, 183.

80 Patrice Debre, *Louis Pasteur*, trans. Elborg Forster (Baltimore: Johns Hopkins University Press, 1998), 249.

81 Roel Mulder, "What was a 19th century saison really like?" *Lost Beers* (blog), July 3, 2018, https://lostbeers.com/what-was-a-19th-century-saison-really-like/(accessed December 10, 2022).

82 Ibid.; Phil Markowski, "Saison," *The Oxford Companion to Beer*, 710-711.

83 Mulder, "What was a 19th century saison really like?"

84 "Lambic," High Council for Artisanal Lambic Beers (website), https://www.horal.be/lambiek-geuze-kriek/lambiek (accessed December 9, 2022); Jackson, *World Guide*, 112-115.

85 Jackson, *The New World Guide to Beer*, 114.

86 Jackson, *Great Beers of Belgium*, 68-69.

87 "The earliest use of the term India pale ale was ... in Australia?," *Zythophile*, May 14, 2013, https://zythophile.co.uk/2013/05/14/the-earliest-use-of-the-term-india-pale-ale-was-in-australia/ (accessed December 10, 2022).

88 Dave Gausepohl, "Your Dad's Beer," *All About Beer*, July 1, 2001, https://allaboutbeer.net/article/your-dads-beer/.

89 Rob Walker, "Let There Be Lite," *New York Times*, December 29, 2002.

90 Ibid.

91 Greg Kitsock, "India Pale Lagers: Craft Beer's Category Stragglers," *Washington Post*, September 10, 2013.

92 Eric Asimov, "Lagers Enjoy a Renaissance," *New York Times*, March 12, 2015, D-4.

93 Horst Dornbusch and Garrett Oliver, "Weissbier," *The Oxford Companion to Beer*, 829.

94 Ibid.; Conrad Seidl, "Schneider Weisse Brewery," *The Oxford Companion to Beer*, 717-718.

95 Jackson, *The New World Guide to Beer*, 47.

96 Roger Protz, "Pierre Celis obituary," *The Guardian*, April 19, 2011.

97 Ibid.

98 Patrick Cain, "Tapping a Fresh Beer Market," *Investor's Business Daily*, February 24, 2010, A03.

99 Cain, "Tapping a Fresh Beer Market"; National Public Radio interview with Fritz Maytag, 2010.

100 Geoffrey Chaucer, "The Miller's Tale," *The Canterbury Tales* (New York: D. Appleton & Company, 1870), 91.

101 Author's interview with Tad Stratford, May 20, 2016.

102 Linde AG, *125 Years of Linde: A Chronicle*, 9, https:// www.the-lindegroup.com/en/images/chronicle_e%5B1%5D14_9855_tcm14-233340.pdf.

103 K. Florian Klemp, "Altbier: A nod to heritage," *All About Beer*, November 1, 2015, Volume 36, Issue 5.

104 Jackson, *The New World Guide to Beer*, 71; Brian Glover, "Mild," The Oxford Companion to Beer, 587–588.

105 Author's email exchange with CAMRA, December 2023.

106 Burkhard Bilger, "A Better Brew," *The New Yorker*, November 24, 2008, 88.

107 Bill Owens, interview with the author, May 2012.

108 "Fun with Words," Wôpanâak Language Reclamation Project (website), https://www.wlrp.org/fun-with-words.

109 Mark Dent, "The Forgotten Father of Pumpkin Beer," *The Hustle*, October 31, 2022, https://thehustle.co/the-forgotten-father-of-pumpkin-beer/.

110 Author's email exchange with staff of George Washington's Mount Vernon, November 2022. The first president's estate also confirmed the popularity of brewing and beer in general at Mount Vernon during Washington's lifetime.

111 Michael Jackson, "How Bert Grant Saved the World," *Beer Hunter* (website), www.beerhunter.com/documents/19133-001575.html (accessed January 17, 2012).

112 Jackson, *The New World Guide to Beer*, 58.

113 Stan Hieronymus, *Brew Like a Monk*, 37, 70-73; Jackson, *Great Beers of Belgium*, 241-245.

114 Hieronymus, *Brew Like a Monk*, 72.

115 Michael Jackson, "Beer at the Thanksgiving Table," *Washington Post*, November 16, 1983.

116 Ronald Pattison, "Dortmund," *Shut Up About Barclay Perkins* (blog), September 13, 2007, http://barclayperkins.blogspot.com/2007/09/dortmund.html.

117 Ronald Pattinson, "Classic Horst," *Shut Up About Baclay Perkins* (blog), October 8, 2011, http://barclayperkins.blogspot.com/2011/10/classic-horst.html (accessed November 5, 2022).

TOM ACITELLI is widely regarded as an expert on beer and the beer industry and has written extensively about both for outlets including the *Washington Post*, the *Wall Street Journal*, and *Eater*. Tom was the long-time history columnist for *All About Beer* magazine and has been a guest speaker or moderator at several brewery events and festivals, including the Great American Beer Festival. Tom's prior beer books include *The Audacity of Hops: The History of America's Craft Beer Revolution* and *Pilsner: How the Beer of Kings Changed the World*, which the North American Guild of Beer Writers voted the best book of 2020. He lives in the Boston area.